AMERICAN BIKERS

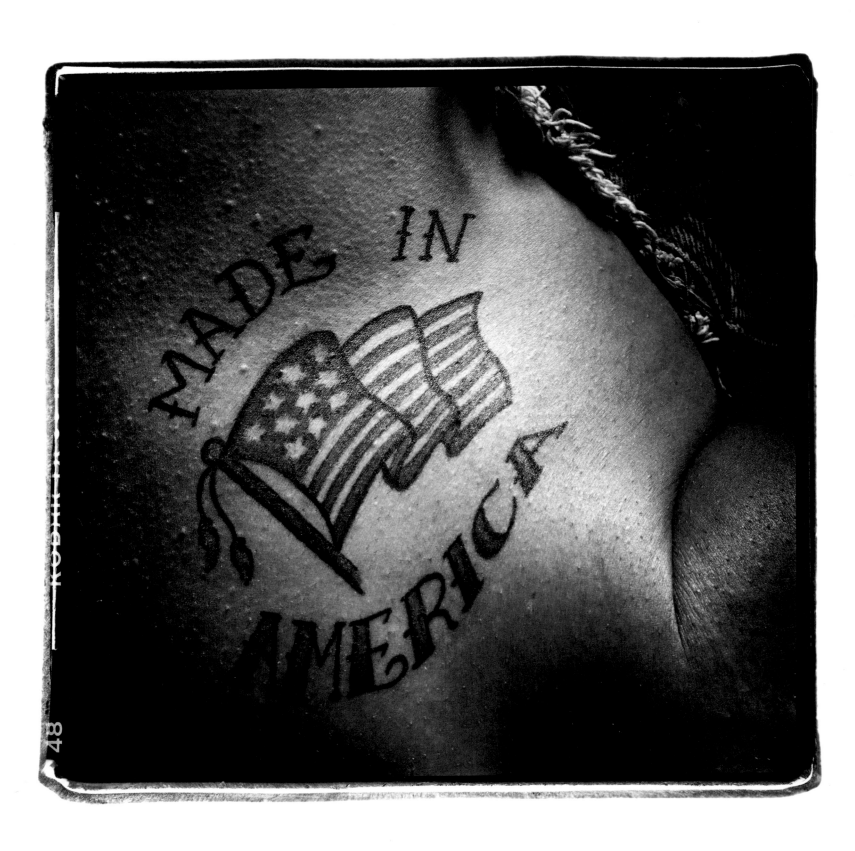

AMERICAN BIKERS
PHOTOGRAPHS BY SANDRO

WITH TEXT BY PROSPER KEATING

te Neues Publishing Company
New York

Grateful acknowledgments:

To Greg and Pat Samata who backed me faithfully and did the first design
which captured the eye of my book agent Roger Conover. Roger thank you for your continual kind
words, encouragement and knowledge; without you this book would still be a dream.
To Lothar Schirmer who saw something in me and my work and gave me a chance to be published
by Schirmer/Mosel - I am honored. To Prosper Keating for writing the prologue for this book.
To Ron Gordon for his fine quality printing. To Donald Washow, Mike Miller, Steven Rapp, David Vacula,
Jon Veleas and Rio Martinez for their hard work and dedication of long hours for this project.
And last but not at all least Hasselblad and Kodak for their continual production
of fine quality equipment and film.
To all I thank you.

Sandro

Published in the U.S. and Canada
by te Neues Publishing Company, New York

Typesetting by Typograph, Munich
Separations by Nova Concept, Berlin in Novatone®
Printed by Passavia, Passau
Bound by Conzella, Munich

ISBN 3-8238-0369-7
A Schirmer/Mosel Production

To my beautiful children Nathan and Natalia Miller

On July 21, 1947, *Life* magazine carried an article about the takeover of a small Northern Californian town on July 4, 1947 by hordes of bikers who terrorized the townsfolk for two days: "4,000 members of a motorcycle club roared into Hollister, California, for a three-day convention. They quickly tired of ordinary motorcycle thrills and turned to more exciting stunts. Racing their bikes down the main street and through traffic lights, they rammed into restaurants and bars, breaking furniture and mirrors. Some rested awhile by the curb. Others hardly paused. Police arrested many for drunkenness and indecent exposure but could not restore order. Finally, after two days, the cyclists left with a brazen explanation: 'We like to show off. It's just a lot of fun.'"

Life's article was accompanied by a now-famous photograph of a beefy, leering biker lounging on a customized Harley-Davidson parked outside a bar, swigging from a bottle of beer, a sea of empties surrounding his bike, watched by a shocked citizen. With other national and local newspapers and magazines carrying similarly sensationalist accounts of what came to be known as the Hollister Riot, a new, terrifying threat to law and order and the American Way of Life was indelibly etched into the paranoid subconscious of Middle America, underscoring a well-developed fear of other threats like Communism and Martians. The outlaw biker had arrived to take his place in the line-up of American bogeymen like the Indians, Communists, Quantrill's Raiders, Tojo and anyone who parted his hair to the left.

The beer-swigging biker captured for posterity by *Life*'s photographer was widely rumored at the time to have been a drunken trucker recruited from a nearby bar after the real bikers had quit town; the customized or "bobbed" Harley-Davidson probably belonged to one of the small number of bikers hospitalized with minor injuries. Nobody was actually jailed or badly hurt as a result of the disturbances in Hollister, a telling fact ignored by the newshounds who never bothered to

quote the majority of townsfolk and traders who had no complaints about what most of them saw as a harmless expression of high spirits that got a bit out of hand.

Several thousand motorcyclists had ridden into Hollister on July 4, 1947 for an Independence Day sports meeting organized by local motorcycle clubs under the aegis of the conservative American Motorcycle Association. Most of these motorcyclists were Straight Americans, the kind who ran the Stars 'n' Stripes up their personal flagpoles on the well-tended front lawns of their neat homes each morning as their families sang the national anthem. They'd been quick to hang out more flags and bunting when the boys came back from the recent war, and just as quick to disapprove when some of the boys proved unable or unwilling to slot back into society. Just as they disapproved when some of the boys in Hollister that summer weekend preferred to sit in the sunshine drinking beer, swapping stories about biking or about places they'd been, things they'd seen in the war that had taken the best years of their lives while Middle America stayed home and mowed the lawn.

Some of the young bikers in Hollister that weekend, amongst them a few of the West Coast biker gangs like the Booze Fighters and the Pissed-Off Bastards of Bloomington, drank too much beer and wine and indulged in some drunken drag-racing along San Benito Street, Hollister's main strip. After one of them was arrested for pissing in public, a few of his friends marched on the town jail to demand his release. When the police chief refused, they rampaged up and down the main drag, shouting and hollering, breaking beer bottles, and exposing themselves to passing townsfolk, requiring the drafting-in of forty state troopers to assist Hollister's seven-man police force in restoring order. The situation was calmed down without serious incident and the bikers left town peacefully, having considerably boosted local traders' profit margins.

Many outlaw bikers and those who emulate them see the Hollister Riot as the genesis of outlaw biker culture, a term that carries echoes of America's past, a past inhabited by misunderstood outlaws, avenging lawmen, scalp-hunting Indians, grizzly-wrestling mountain men, lonesome cowboys serenading the stars under a coyote moon, and assorted heroic loners defending liberty with a brace of six-shooters. Many American bikers, perhaps even some of those photographed by Sandro Miller on his travels throughout the United States, see themselves as a living link to this past, as guardians of Western Tradition and The Old American Ways.

Some of Miller's portraits are reminiscent of the work of earlier American photographers, like Mathew Brady and Edward Curtis, not because he is trying to copy their style but because many of his subjects look rather like the people, Whites and Indians alike, immortalized by Brady and Curtis. Some of Miller's images remind me of the haunting yet sensitive Sioux and Apache studies by the nineteenth-century American photographers Ben Wittick and Charles Bell, while others evoke memories of the Marlboro Cowboy's fast-disappearing America, an America untamed by shopping males, Oprah Winfrey, and luminous nylon leisure wear. Many of these faces belong, sadly, to another epoch. They evoke an America that is long gone, swept away by the winds that whistle across the prairies and through the mountains of a hundred Hollywood westerns. They have the rugged, weather-beaten faces of people who spend their lives in the open, exposed to the elements, facing the wind, the translucent thousand-yard stare born of scanning distant horizons across the vastness of the American hinterland.

For many of them, the outlaw biker lifestyle offers an escape from the drudgery of late twentieth-century daily life, a return to the Old American Ways, their motorcycles iron horses to carry them along the trail of American heroes of popular fiction and culture. There are even

those who go as far as to wear six-shooters on their hips as they roam the highways on their Harley-Davidsons. At one time, many American motorcycles, Harleys and Indians in particular, were fitted with left-hand throttles to leave the rider's gun hand free for shooting on the move – although the factories probably had law enforcement rather than hell-raising in mind.

Of course, not every biker wearing outlaw-style colors on a customized Harley or a chopper of whatever mark is a gun-toting outlaw in the extreme mold of the Hell's Angels or the Pagans. There are various riders' groups and clubs, such as the Harley Owners Group or "HOG," backed by the factory, the Christian Motorcyclists Association or "God Squad," and all sorts of veterans' outfits, whom the genuine outlaw gangs permit to wear outlaw-style colors and patches. Motorcycle manufacturers are keen to fuel the outlaw image because it sells motorcycles to men and women who want a machine just like the one they never had when they were young or the one they had to sell when the first baby arrived.

Japanese firms like Honda and Yamaha have cashed in with Harley-style custom bikes on a trend shaped by advertising executives and lifestyle magazines since the late 80s, but Harley-Davidson reigns supreme in the retro-style stakes, cunningly turning obsolescence into profit on the crest of a wave of nostalgia. People with dollars to burn fall over themselves to own a throbbing example of Milwaukee iron and ride back to the past as it never really was in reality. Harley-Davidson has also come up with a range of branded clothing, which is more profitable than their motorcycles, giving customers a choice of mix'n'-match looks from the 50s to the 70s to go with their retro-Hogs.

There is no shortage of events and rallies for these enthusiasts to attend across the United States, but some of the best-known happen in Sturgies, South Dakota, and Daytona, Florida, which has been a biker venue since before World War I. Fifty years after the so-called "Hollis-

ter Riot," the small Californian town opened its streets to thousands of bikers just as it did in 1947. The event? A commemoration of the "riot." The majority of bikers who roared into town, to borrow a phrase from *Life* magazine's report, may have aped the outlaw biker look but with their crash helmets and sober driving habits, the "rioters" were just as straight as 99 percent of the motorcyclists credited with good behavior half-a-century before by the American Motorcycle Association.

If there were any bare-headed young men there with beer and wine on their breath and benzedrine in their veins, twisting their throttles just that bit too far, uttering salacious invitations to passing virgins and spinsters of the parish before dropping the clutch and gunning the engine up the highway to nowhere, the media must have ignored them this time around. The wheel has turned a full revolution.

PLATES

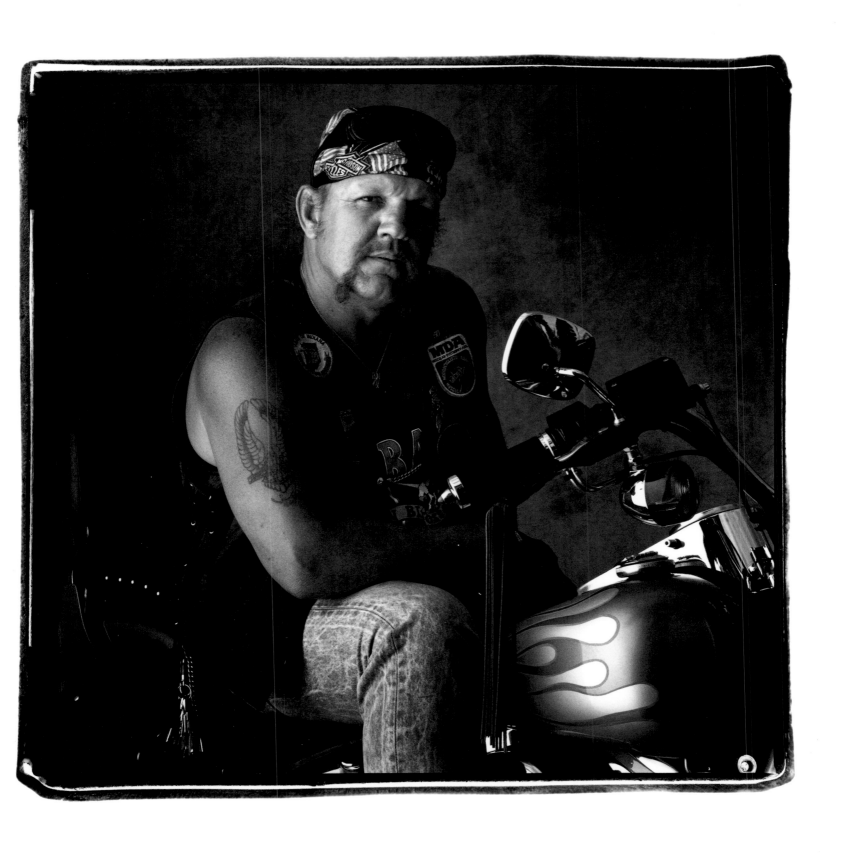

Skip Alexander Greenwood, Indiana

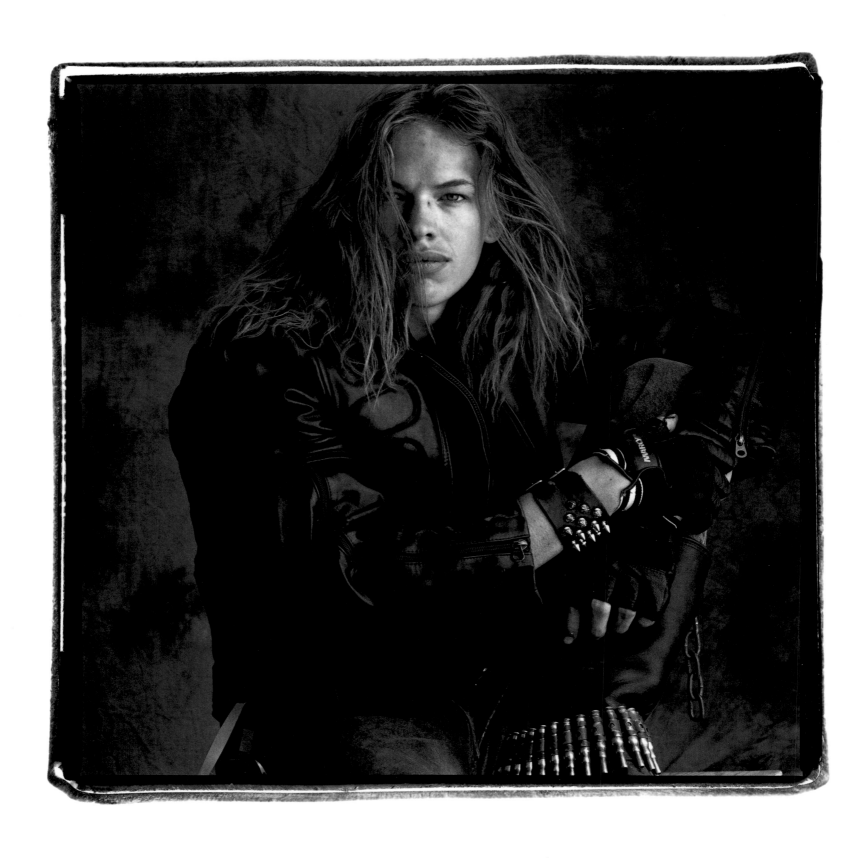

James Root "Tom Cat" Piedmont, South Dakota

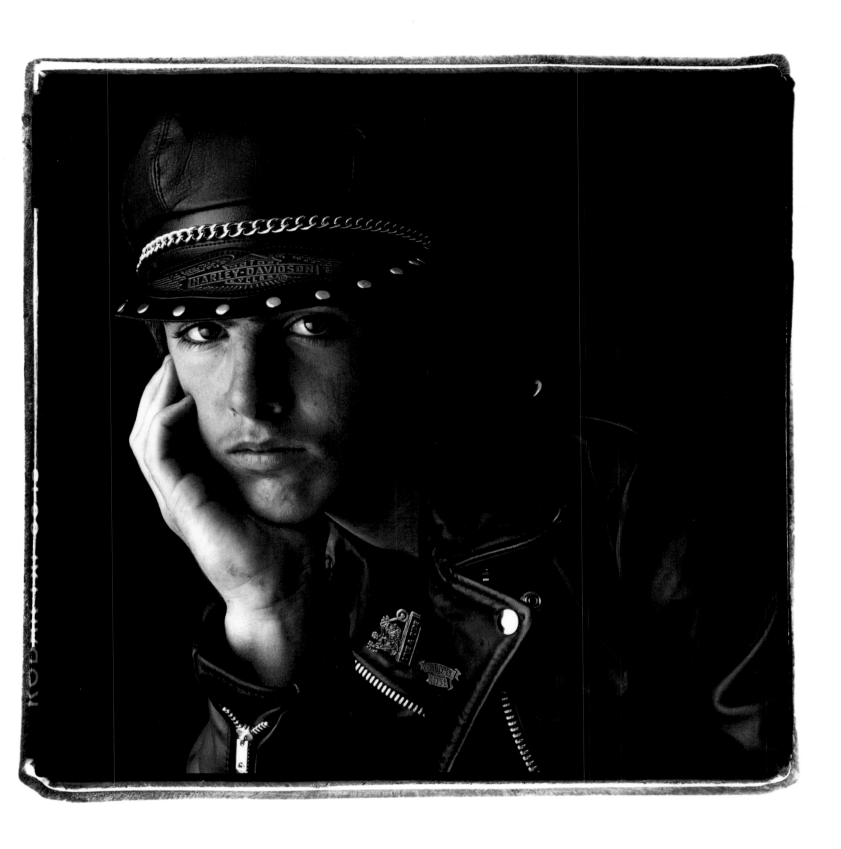

Brent Wildenstein Arvada, Colorado

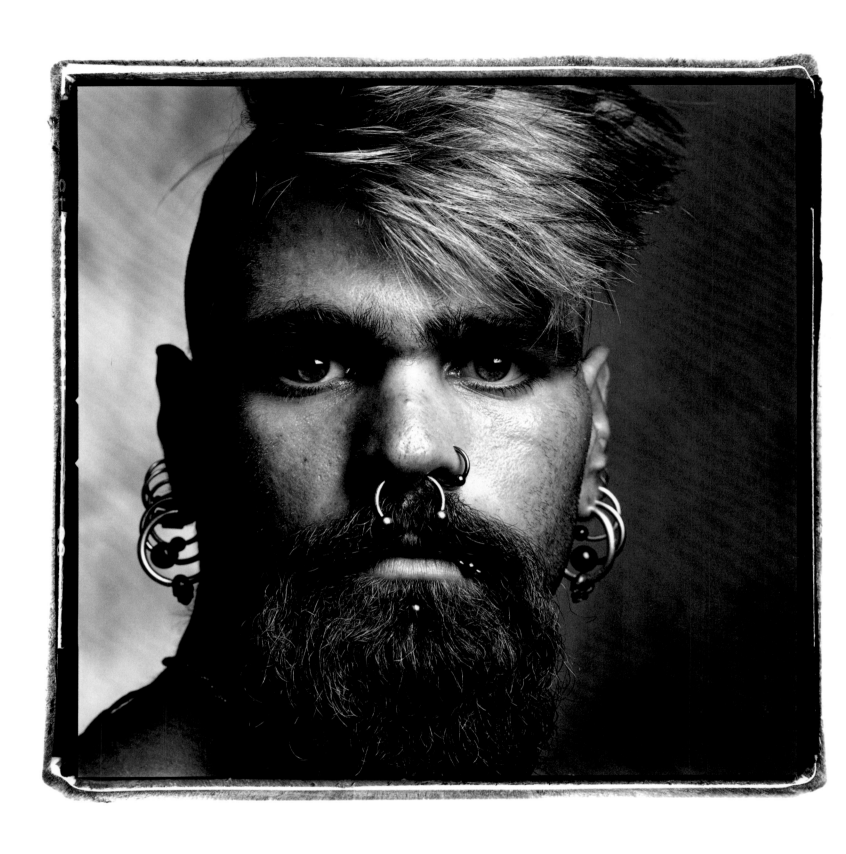

Alex Estes BMW Dayton, Ohio

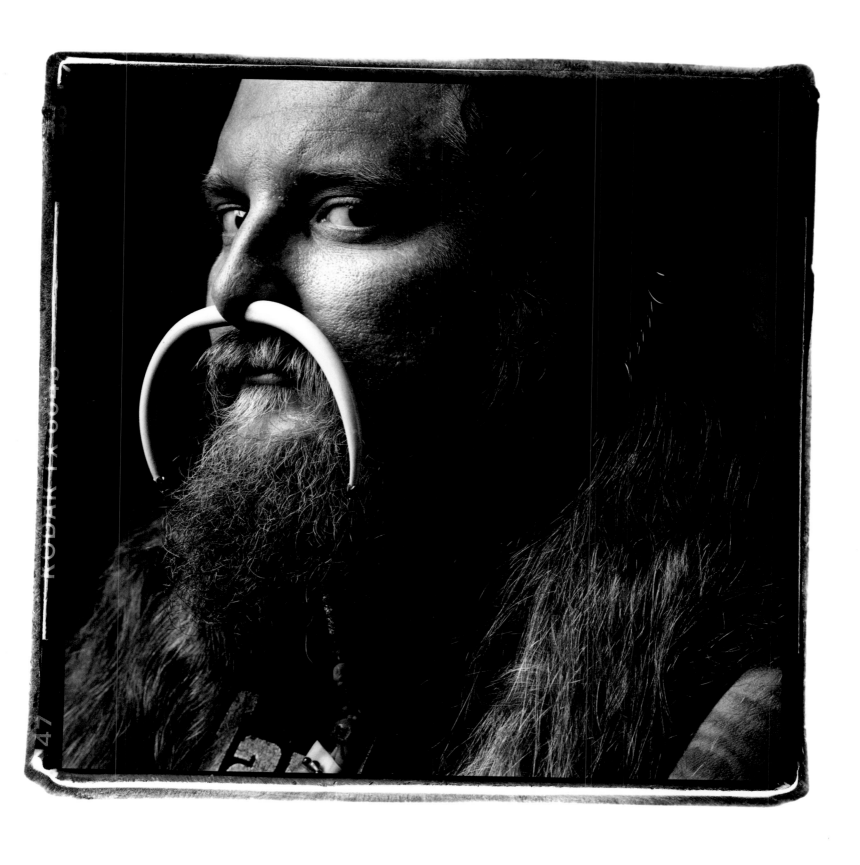

Greg Wilcoxon "Famous Leg Greg" Harley Pan Head Gary, Indiana

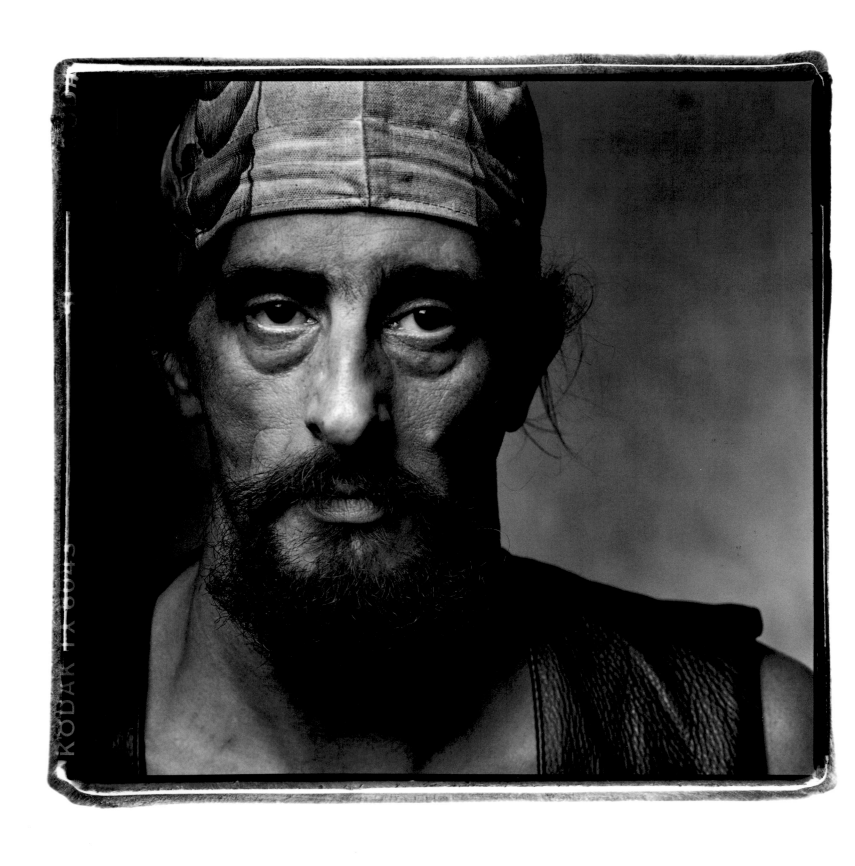

Doug W. Keim "Dirty Doug" 1979 1200 cc Harley Lont Mont, Colorado

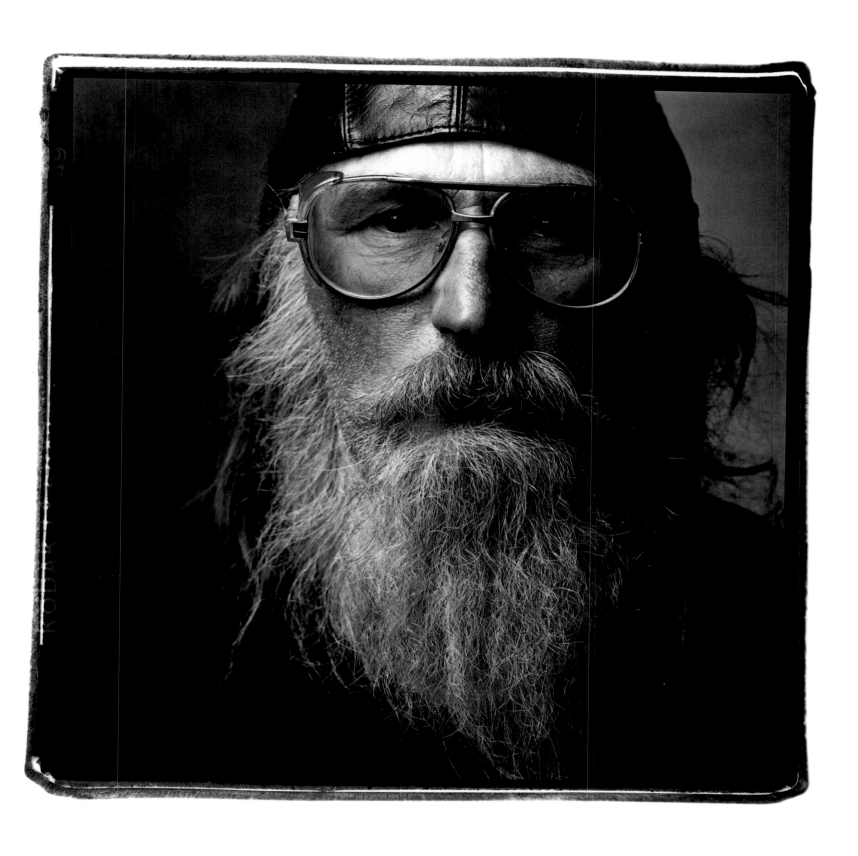

Jack Levell Soft Tail Harley Carter Lake, Iowa

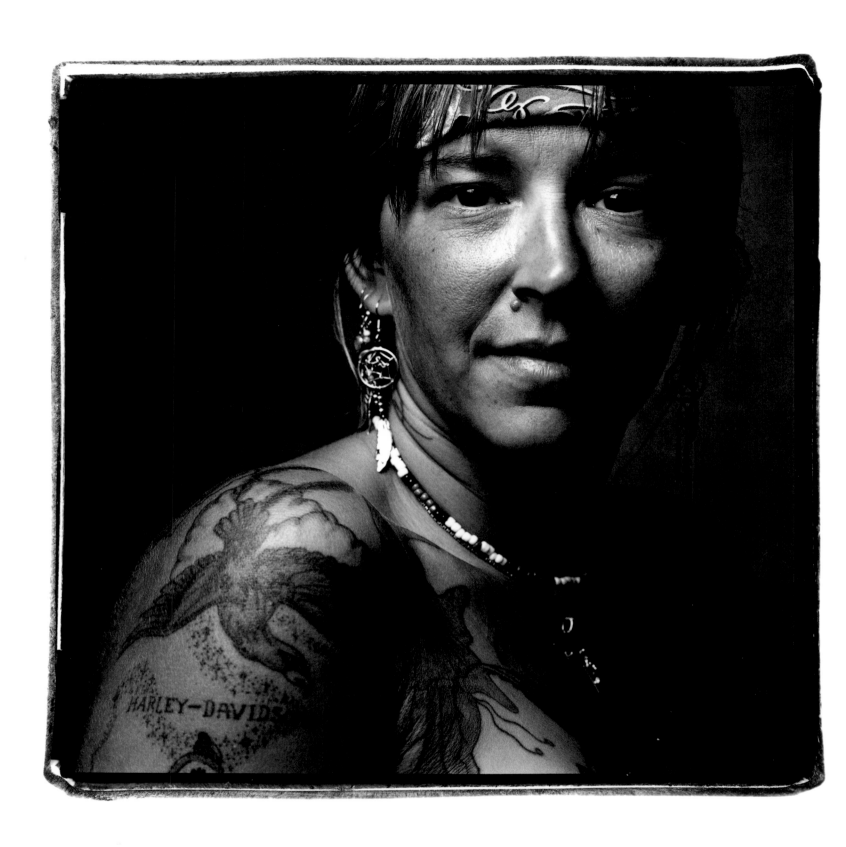

Lee Ann Smith 1993 FXR Springer Marie, Michigan

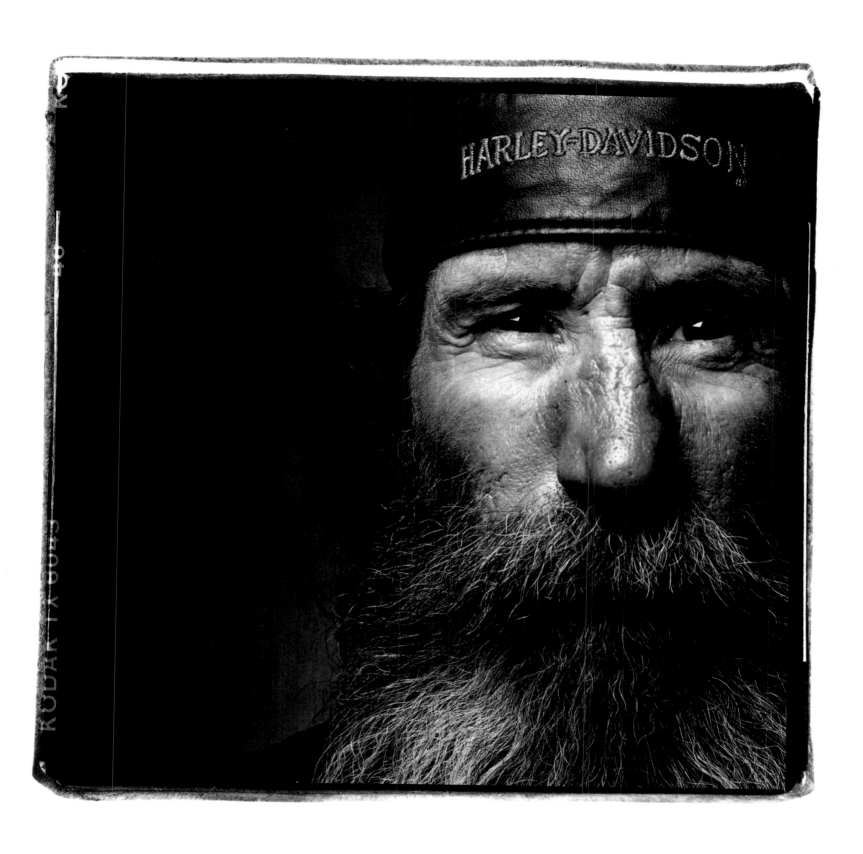

John Swendeman "Father Time" 1988 Harley Springer Page, Arizona

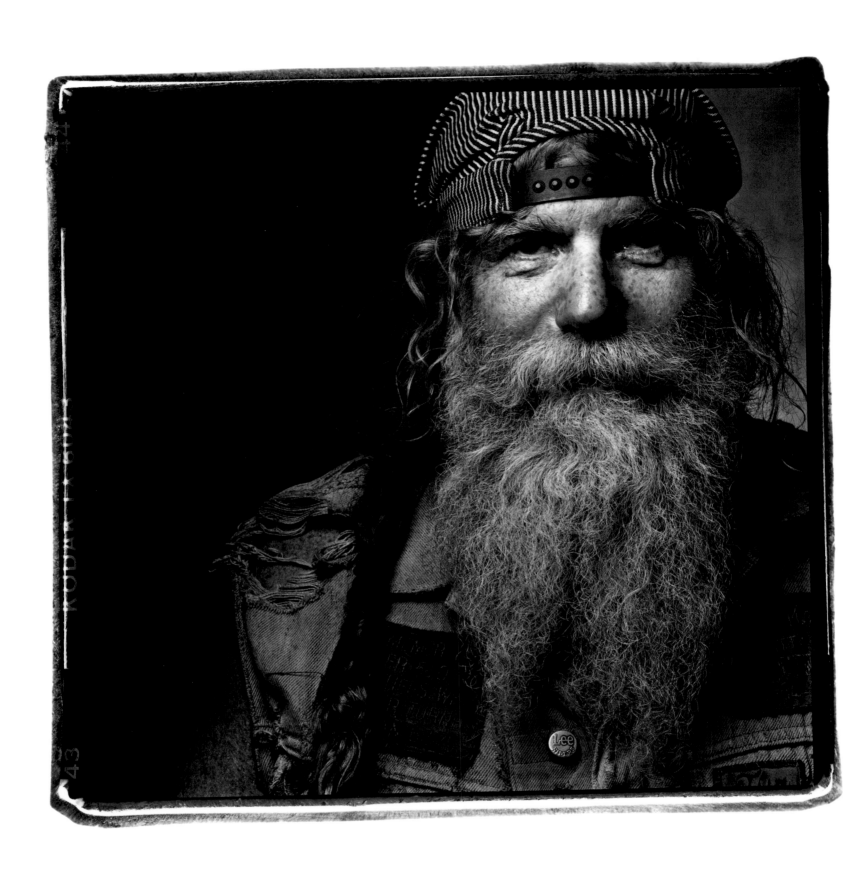

D. Tricamo "Tug" 1986 Soft Tail Harley St. Louis, Missouri

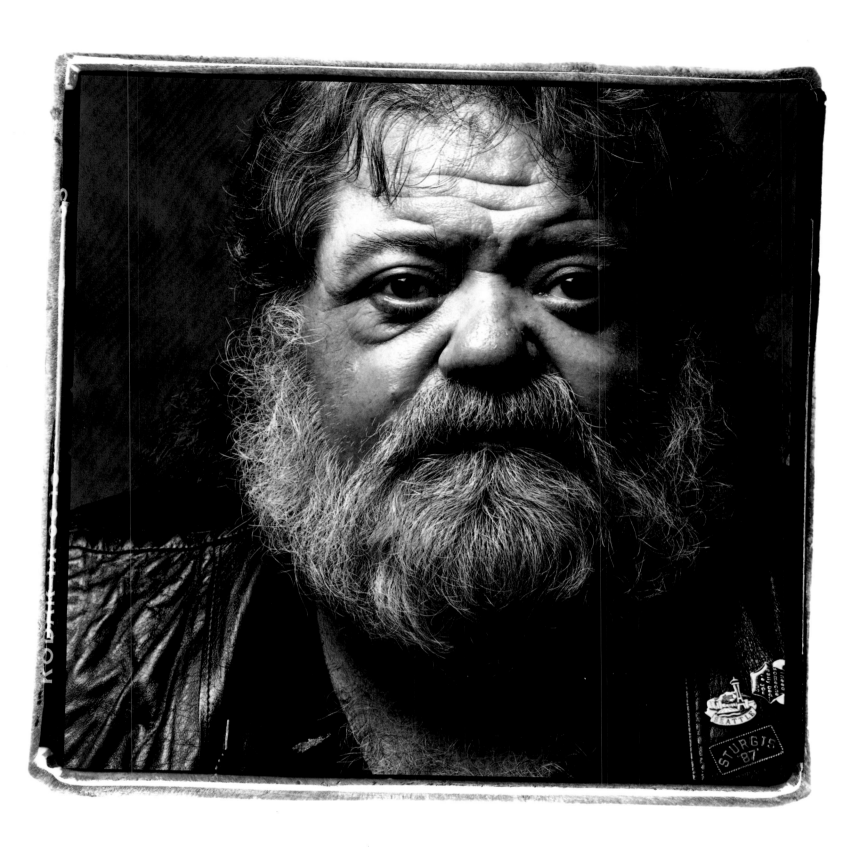

David Beman "Monk" Honda Goldwing Aspencade Madison, South Dakota

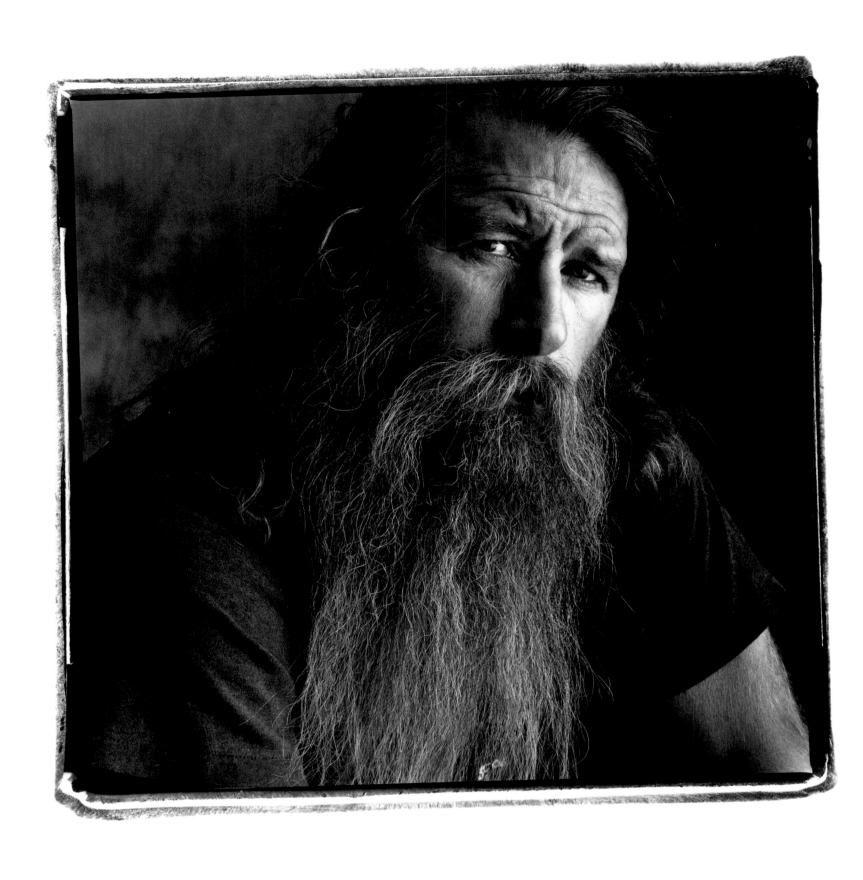

John Reidling Dallas, Texas

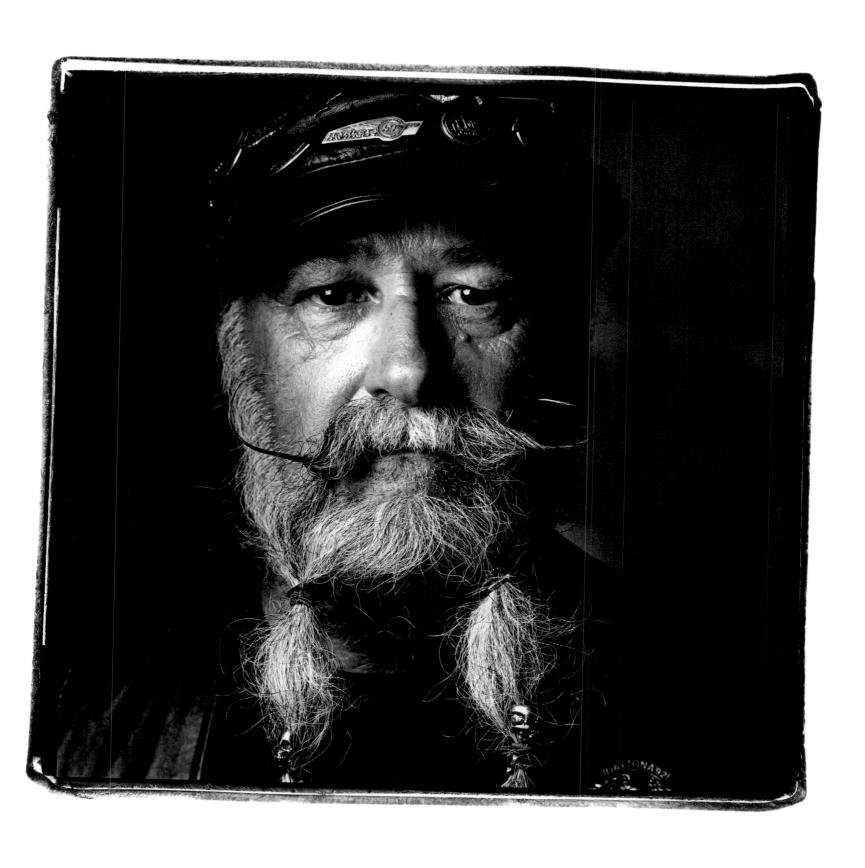

George Allford "Bungee" Soft Tail Harley Streetsboro, Ohio

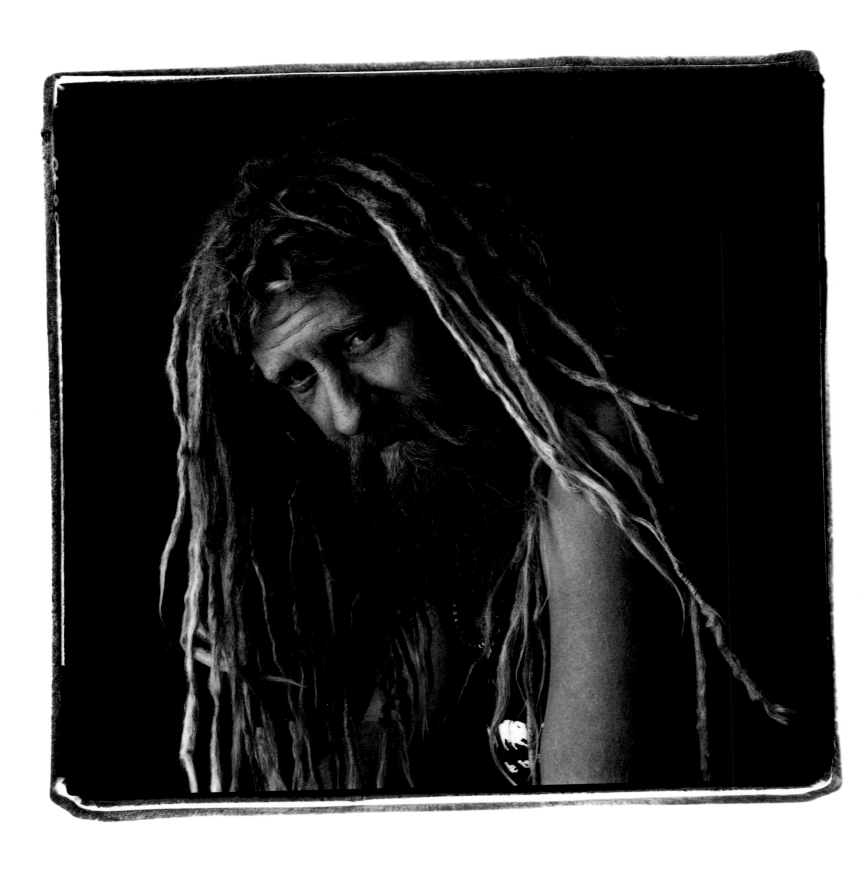

Lester Perkins

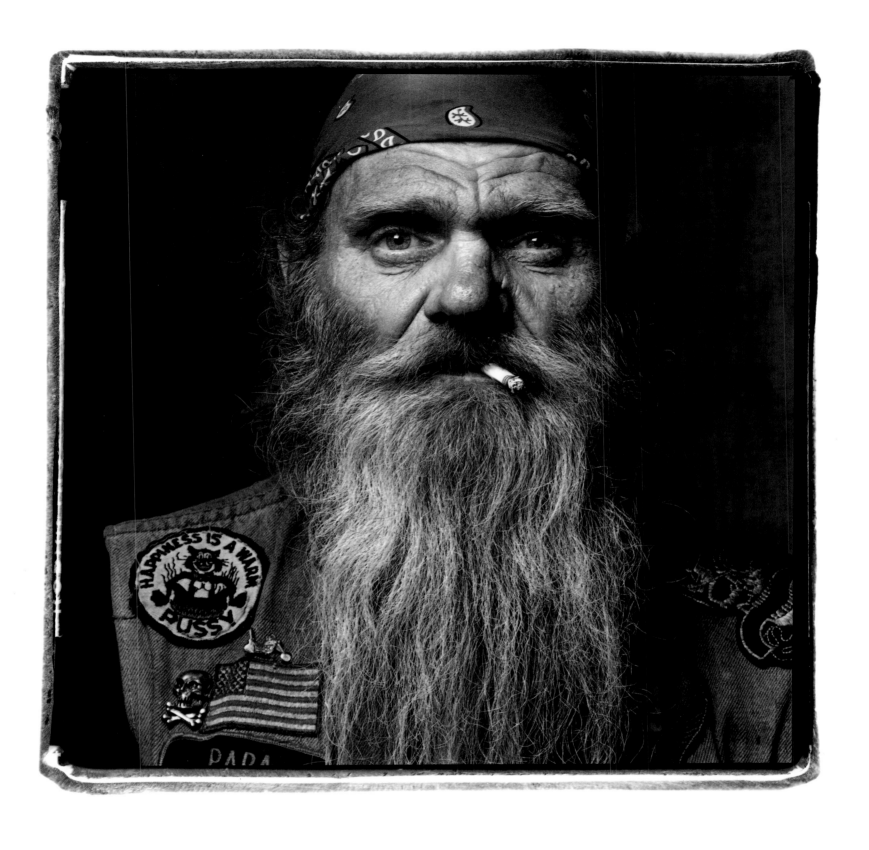

Paul Buneta, Jr. "Pa Pa Smurf" Triumph Bonnie Chopper Collinsville, Illinois

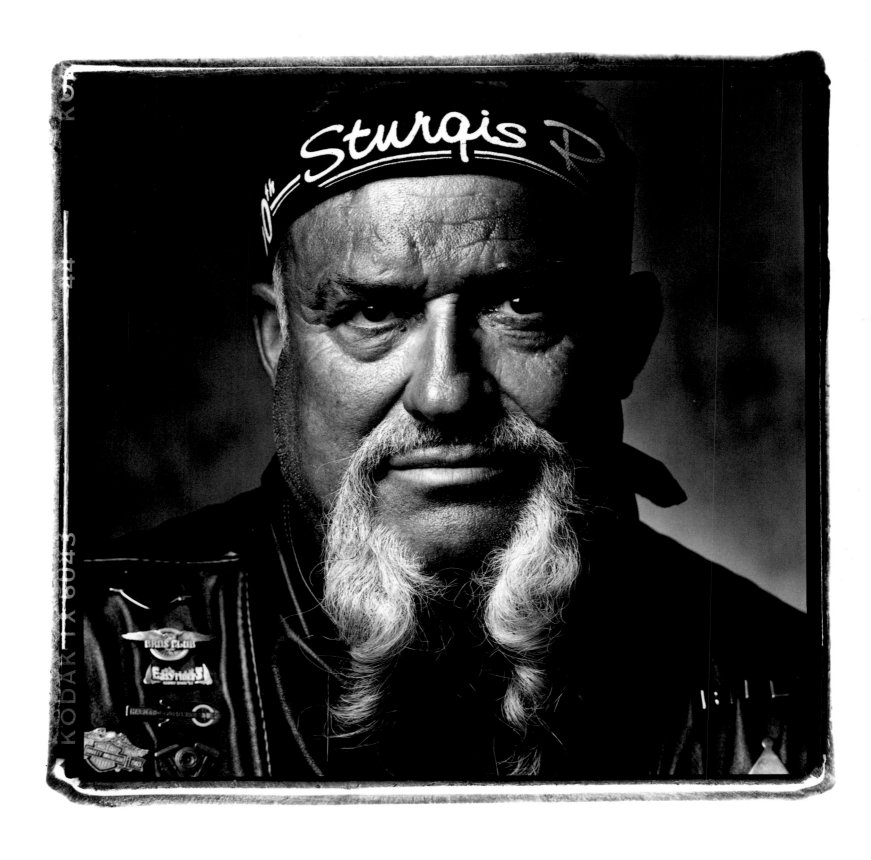

Bill Theis "Wild Bill Theis" **Harley 1991 7XRS** **Hamel, Minnesota**

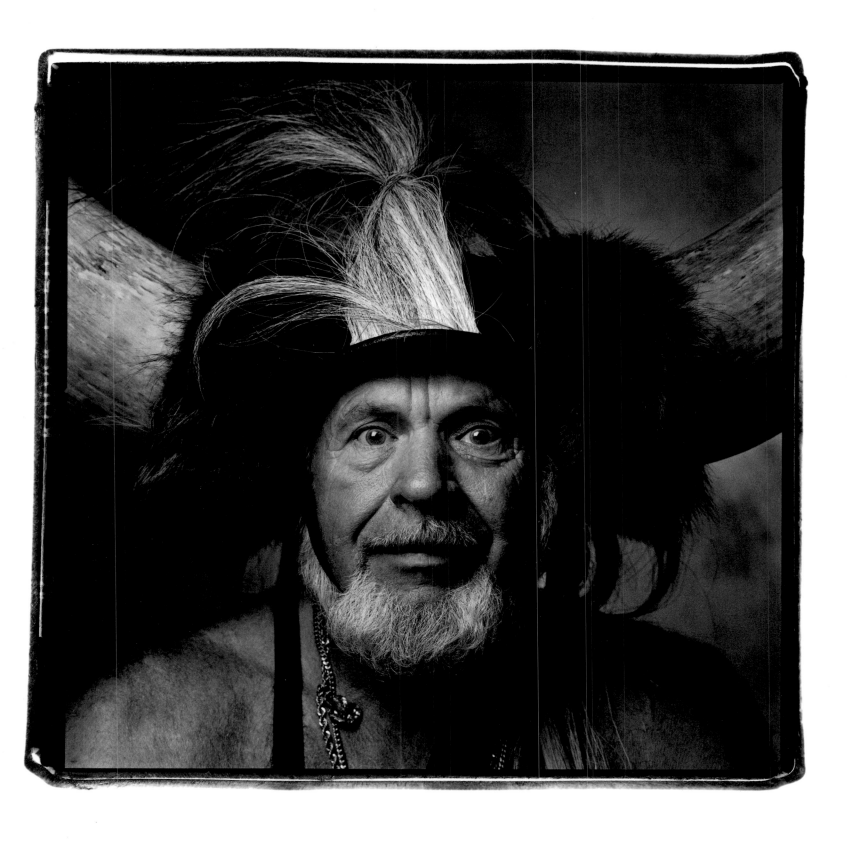

Archie F. England "Horny Man" Honda 3 Wheeler Land O'Lakes, Florida

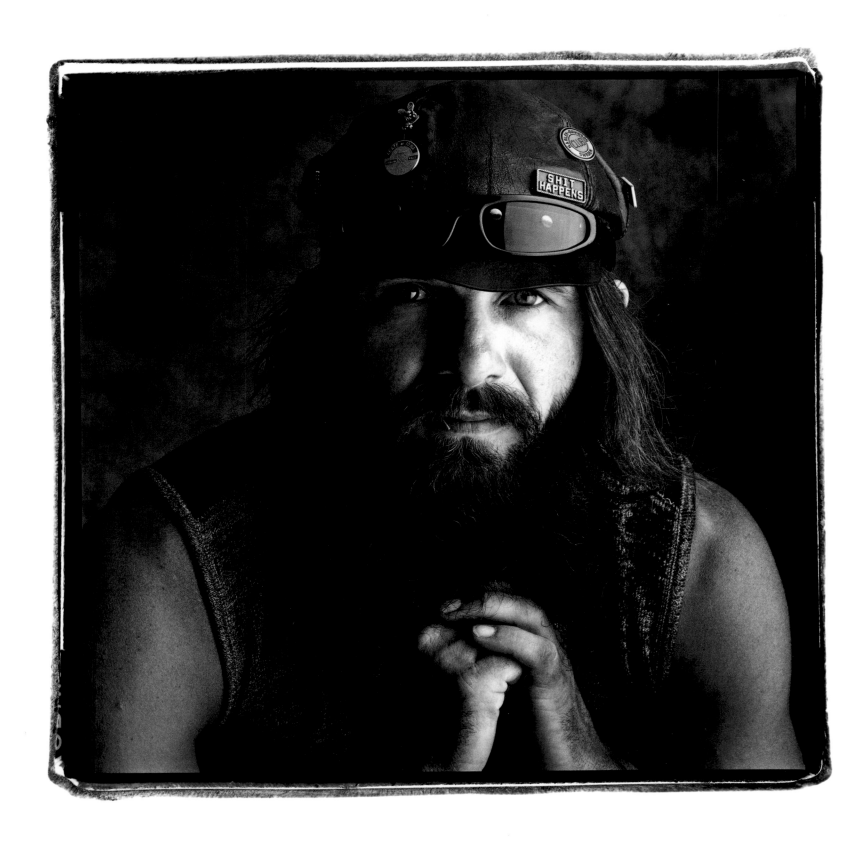

Bruce Silnilke Waukesha, Wisconsin

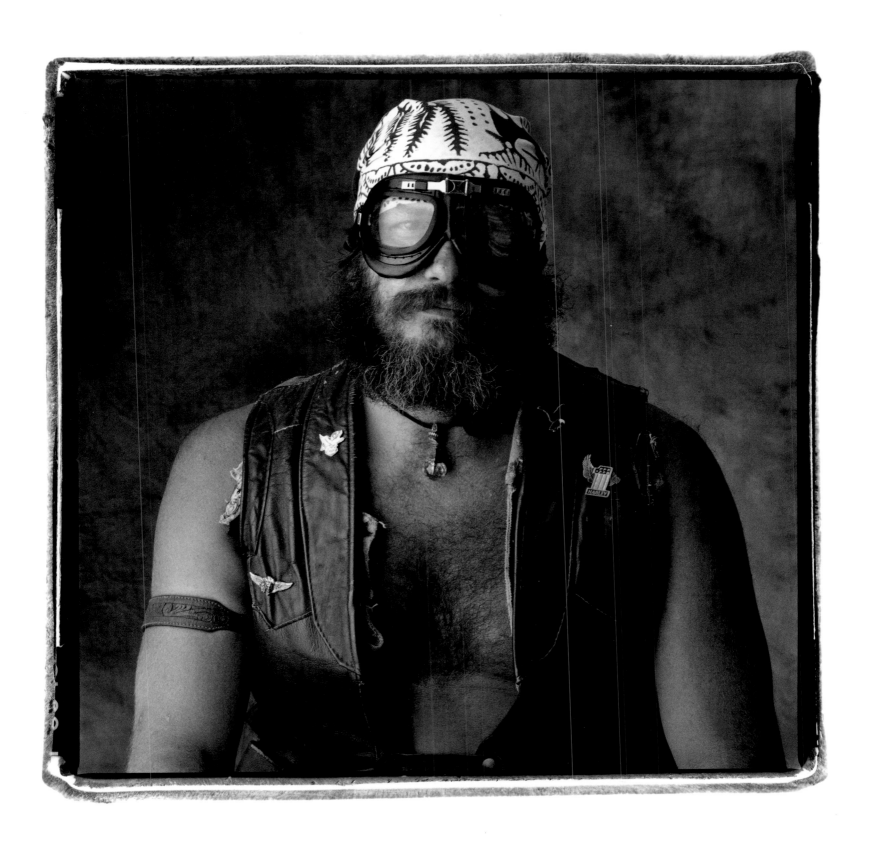

Mike Smith 1966 Pan Shovel Head Gutherie, Oklahoma

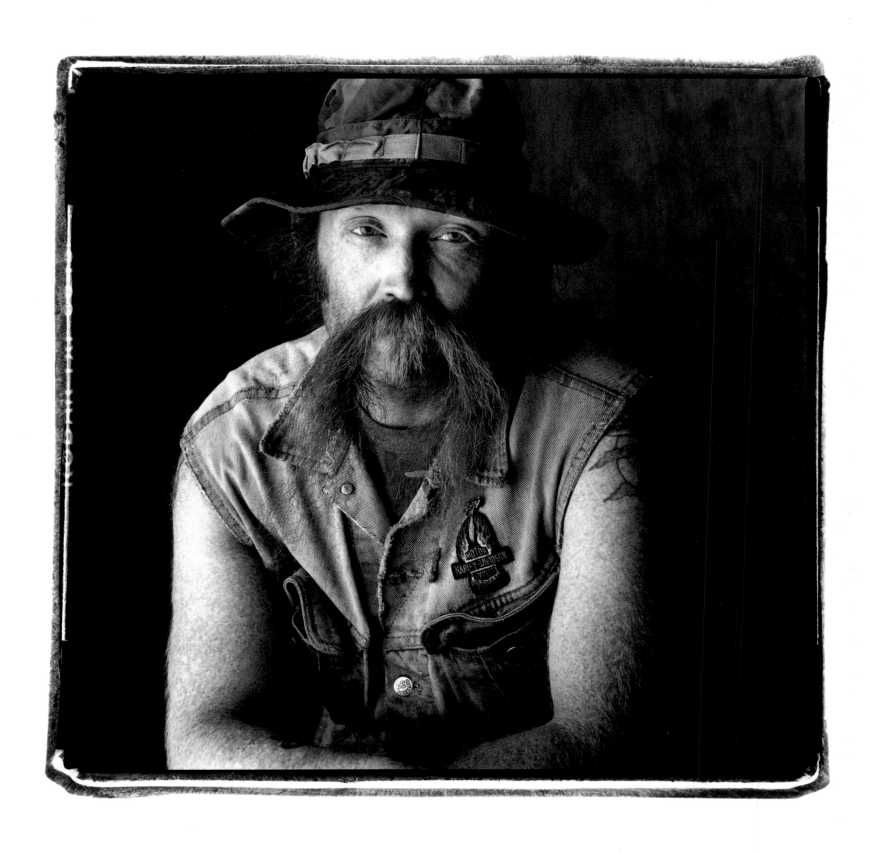

Steven D. Booton "Mr. B." 1988 Super Glide Harley Marshall, Michigan

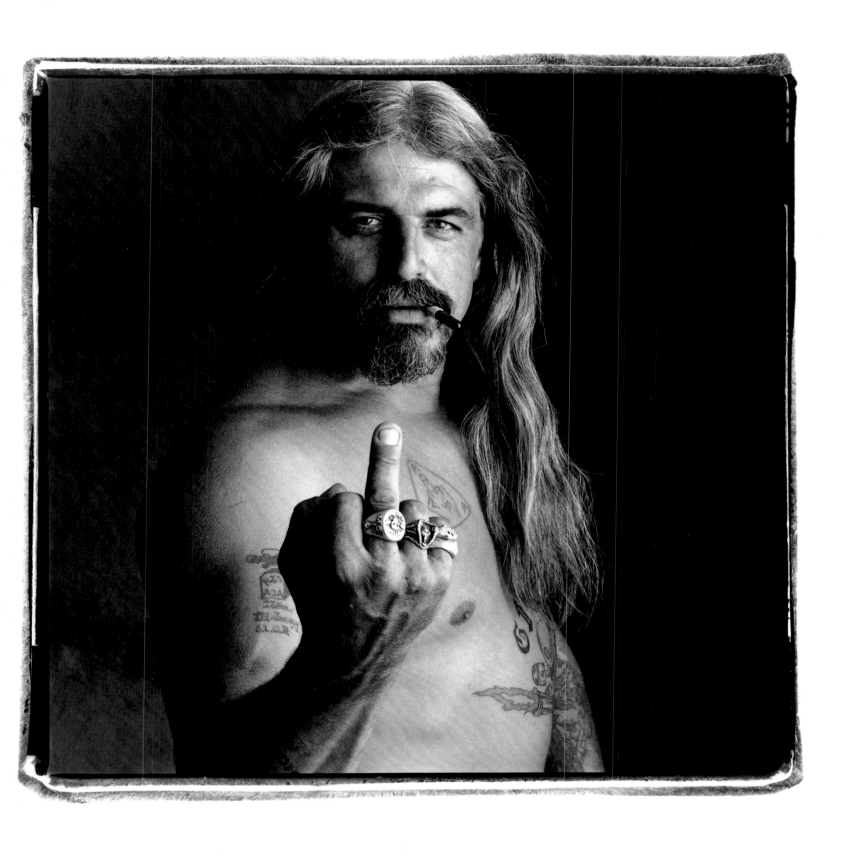

Robert West Gangster

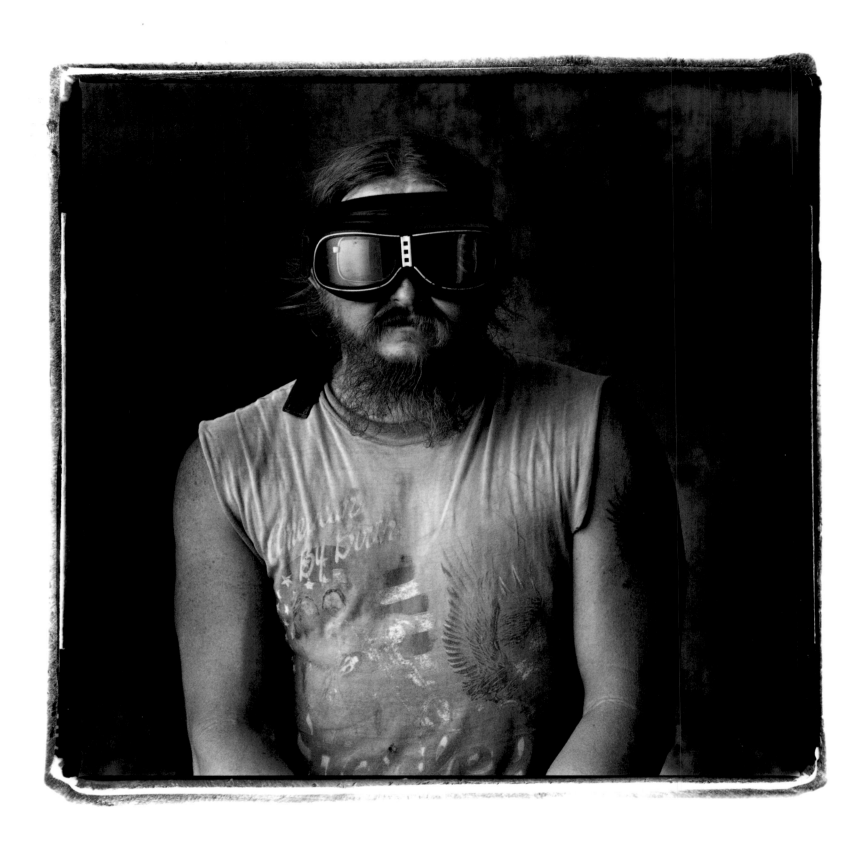

Al Ames 8080 Lowrider Edmond, Oklahoma

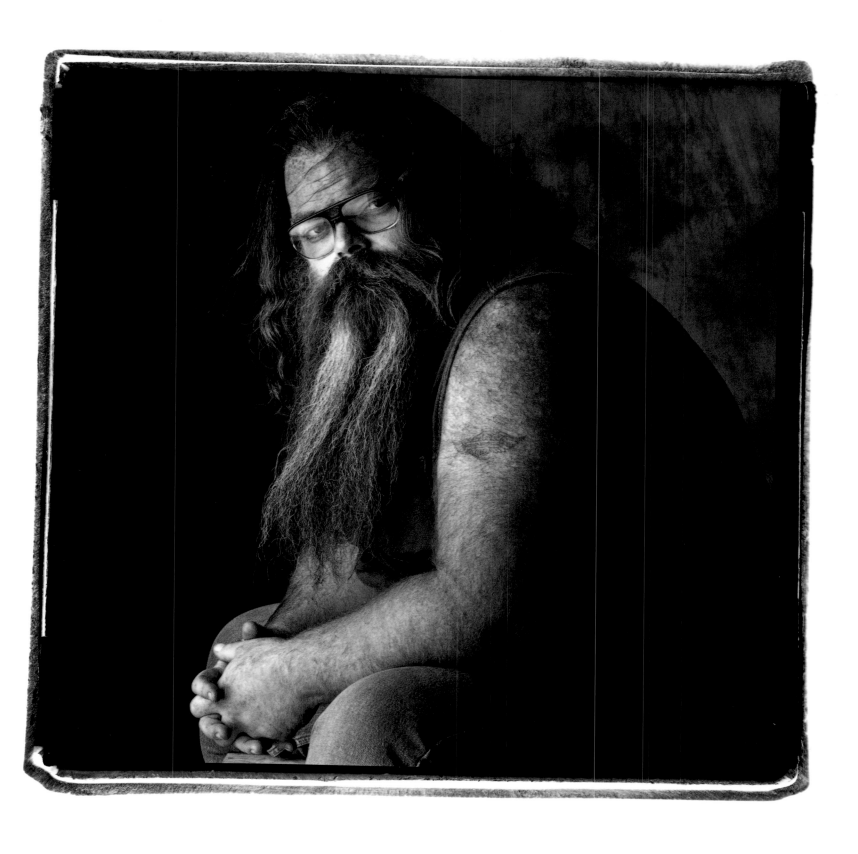

Tim Koontz 1979 Harley Shovel Head Salt Lake City, Utah

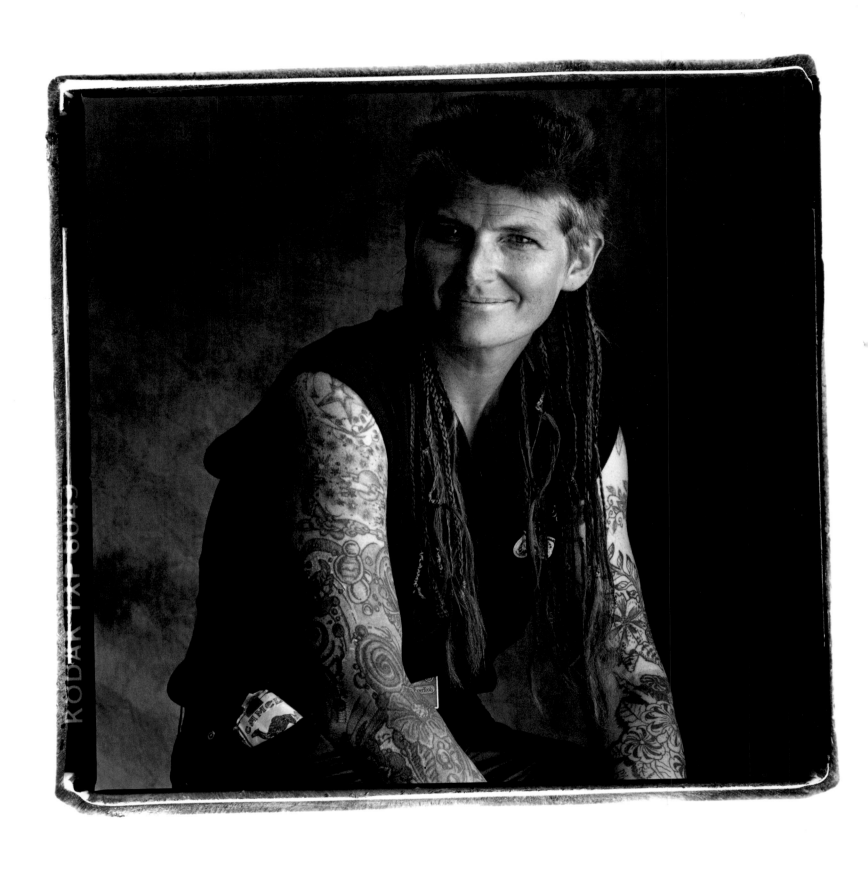

Diane Frandsen 1991 Soft Tail/1977 Shovel Head Rockvale, Colorado

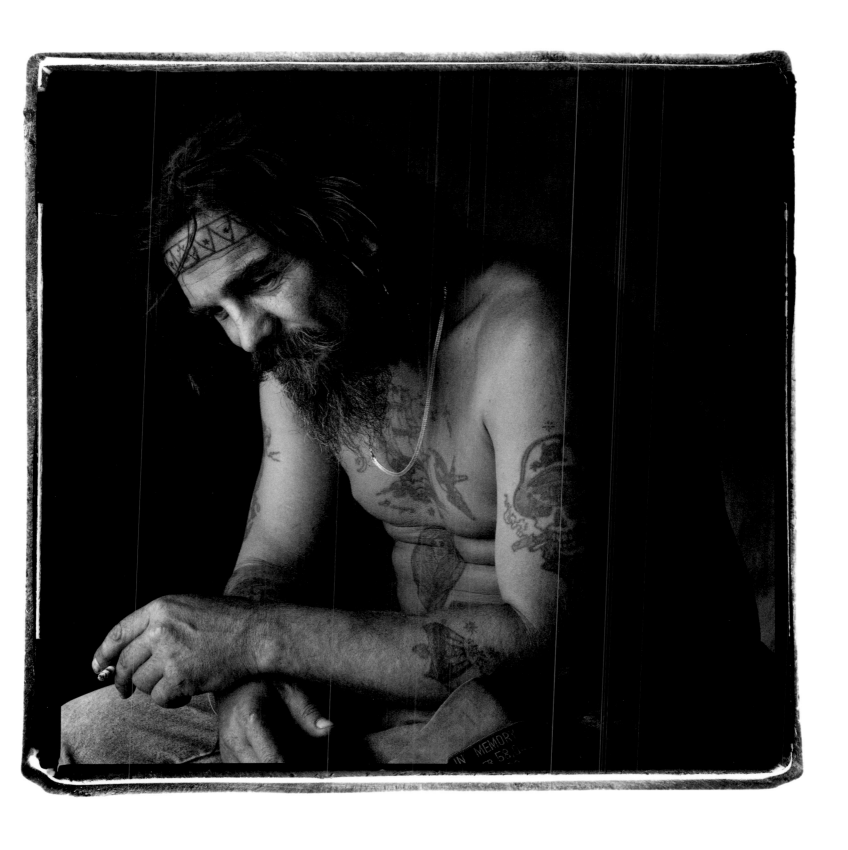

Frank Gicks "Crazy George"

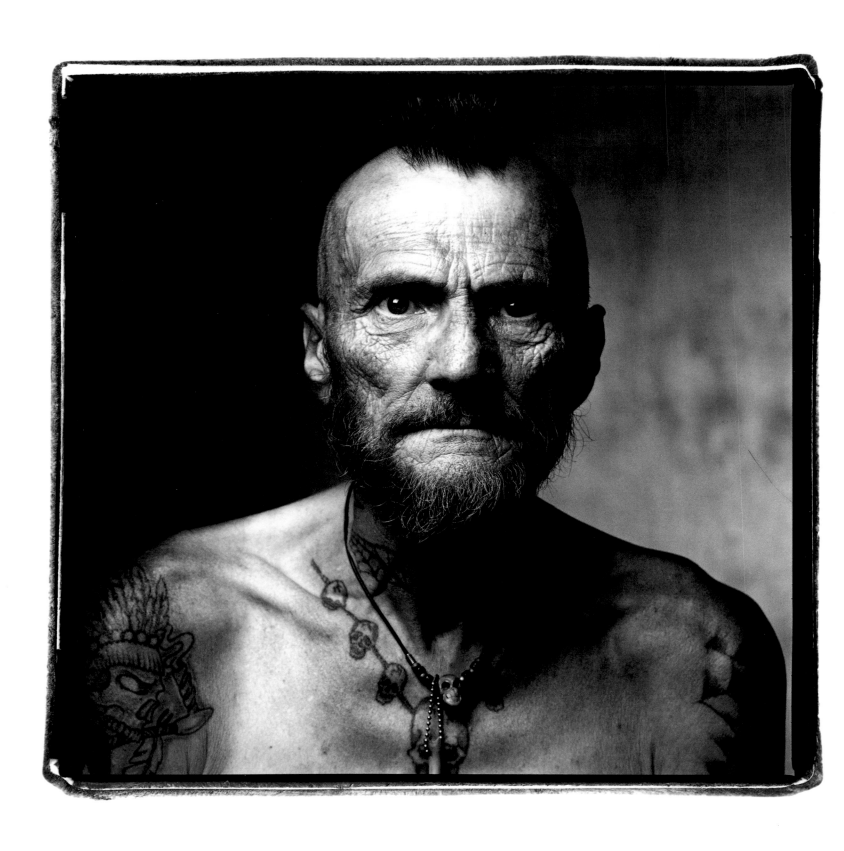

Dick Fields "Bones" 1991 Custom Soft Tail Harley Denver, Colorado

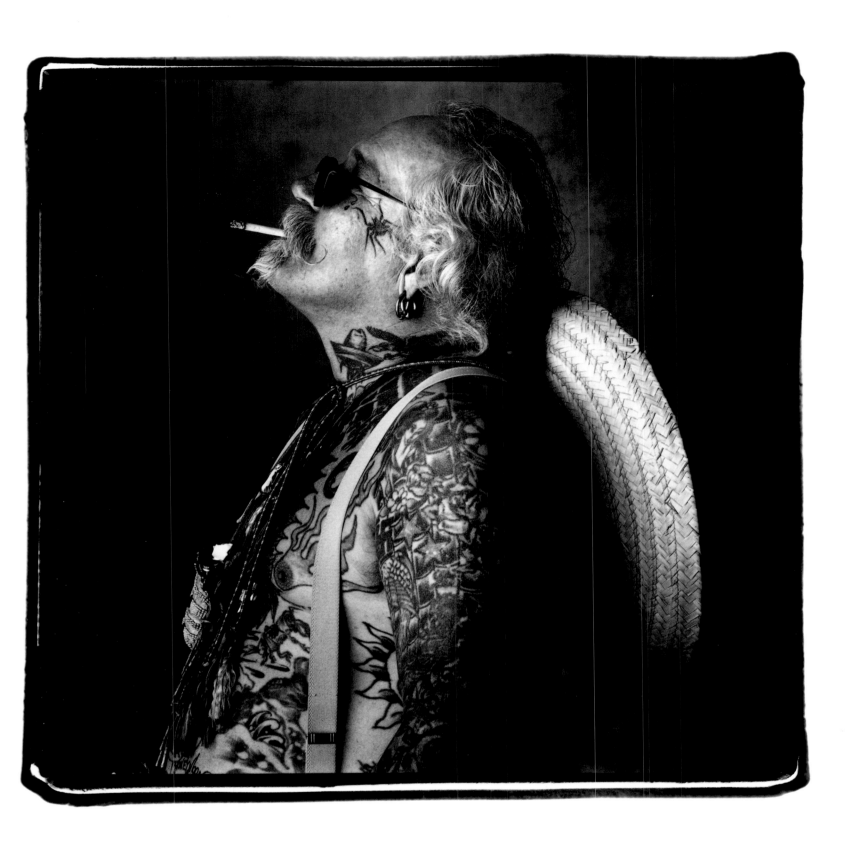

Asa Lee Crow "Crow"

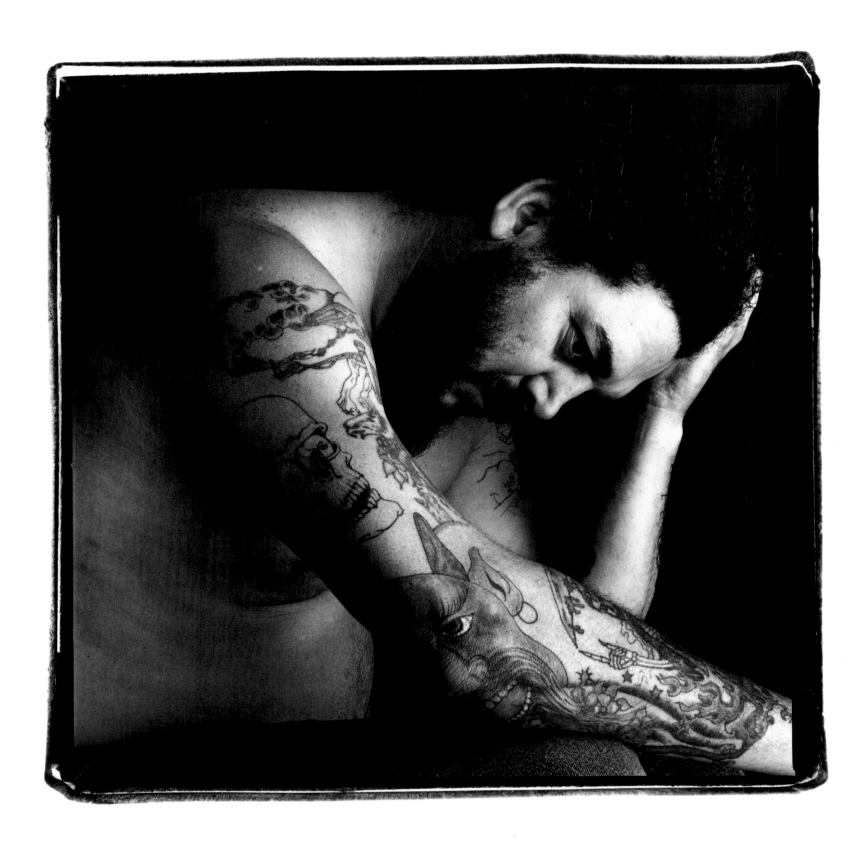

Oscar Rigsby "Bookie" Harley Davidson Dresser Chattanooga, Tennessee

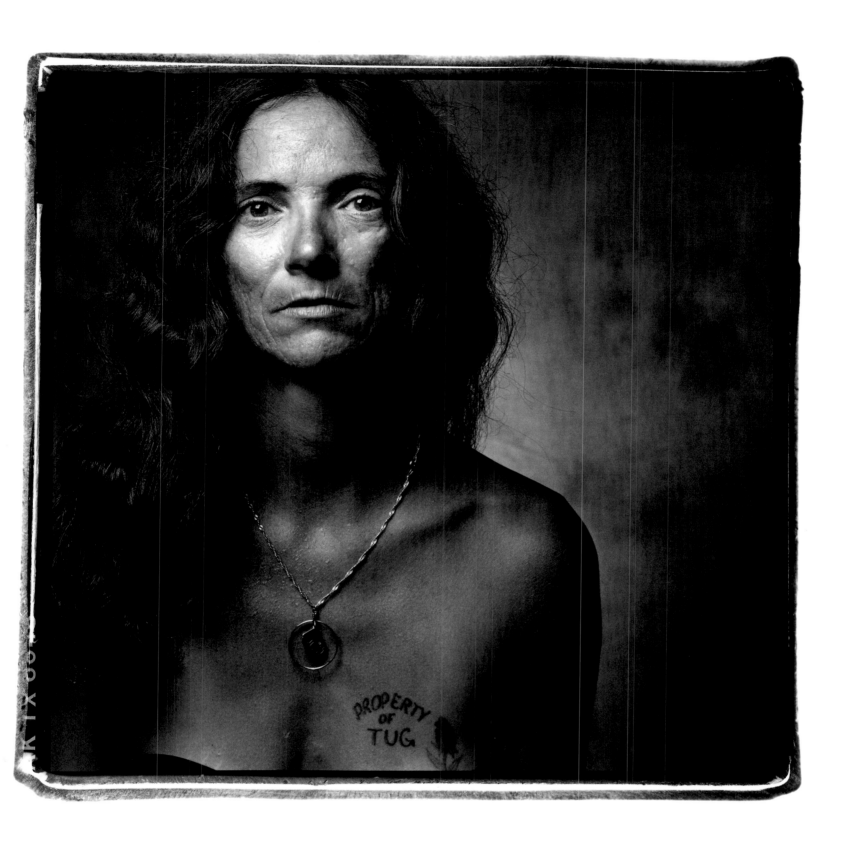

Mary Boyer "Cherokee" **Harley Sportster** **St. Louis, Missouri**

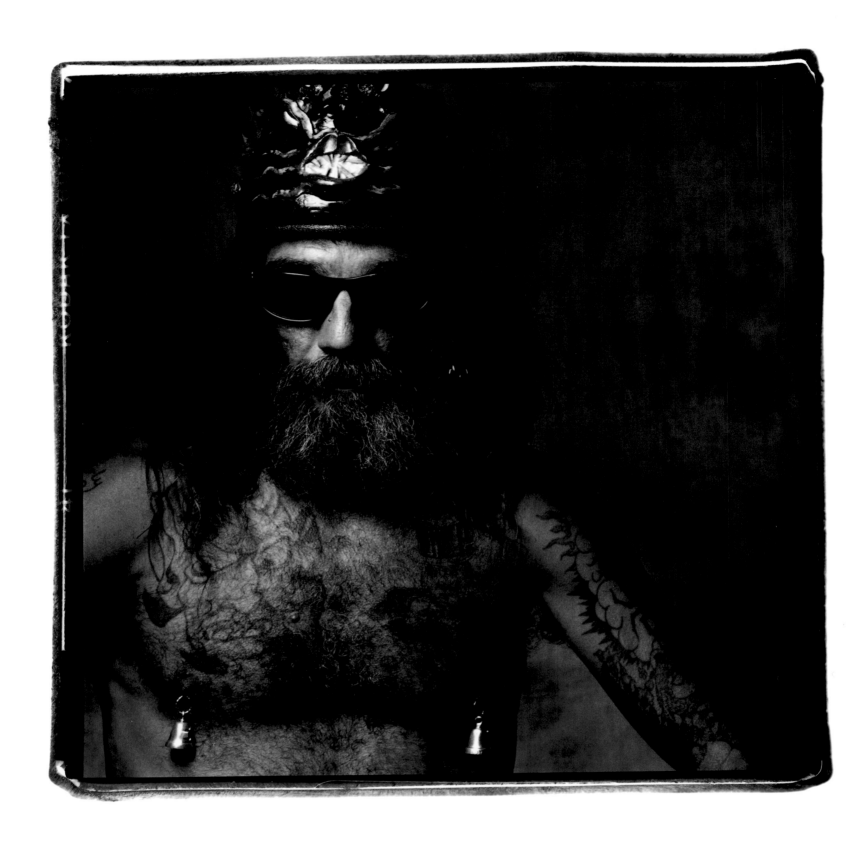

Phil Crimi "Yetay" Soft Tail Harley New Smyrna Beach, Florida

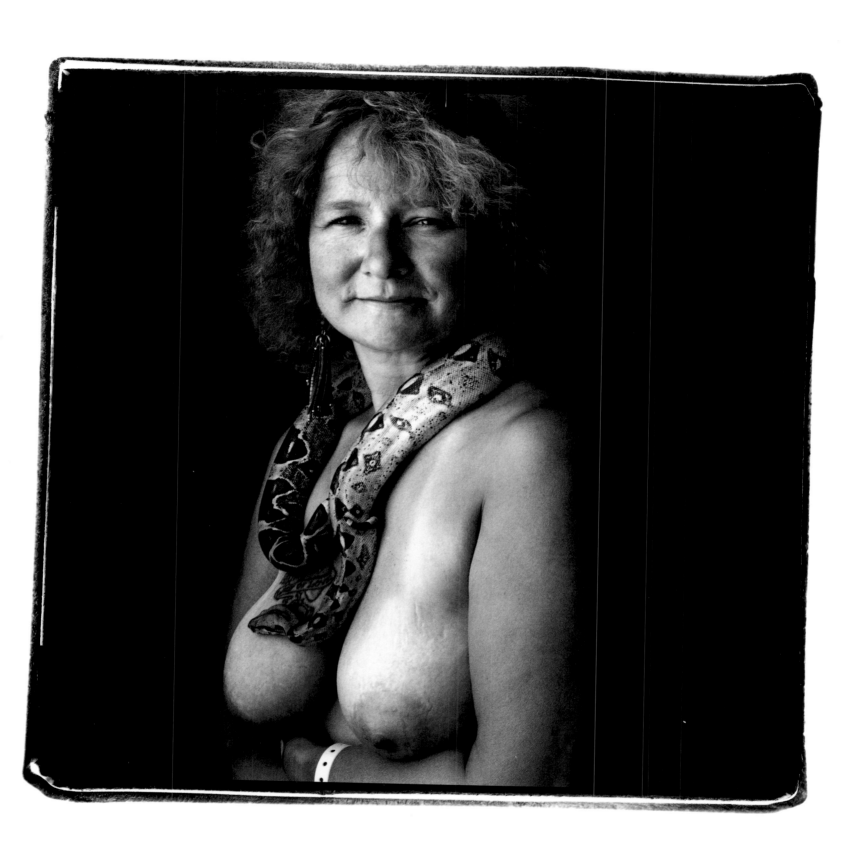

Luci Armstrong Woodbury, Minnesota

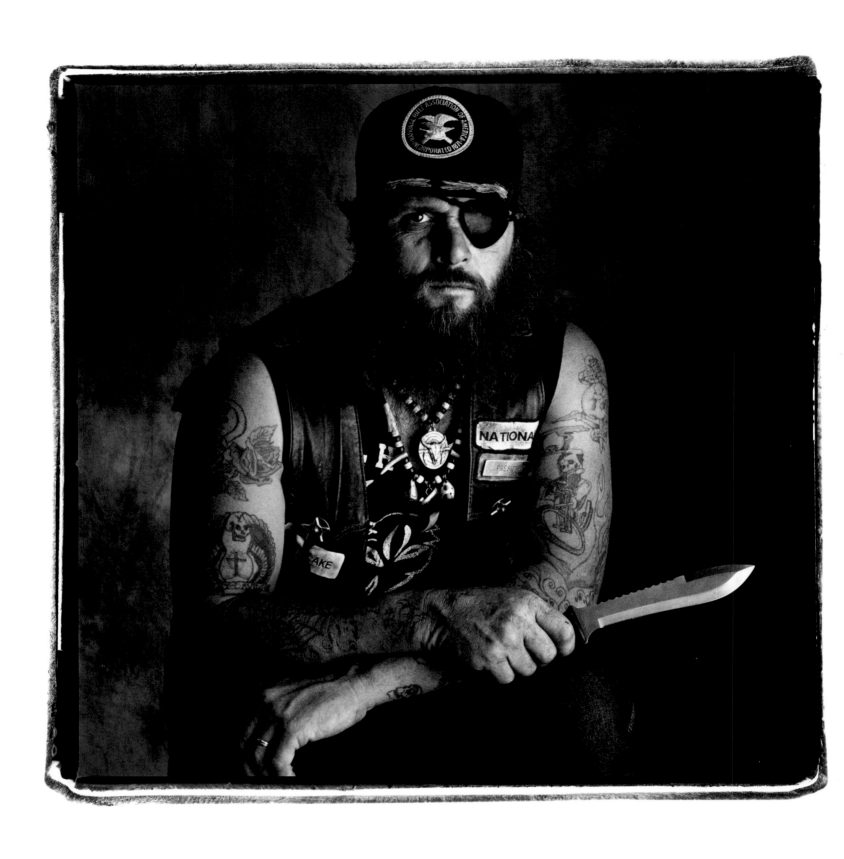

Randy Barber "Barber" 1977 Harley Davidson FLH Electra Glide Danbury, Nebraska

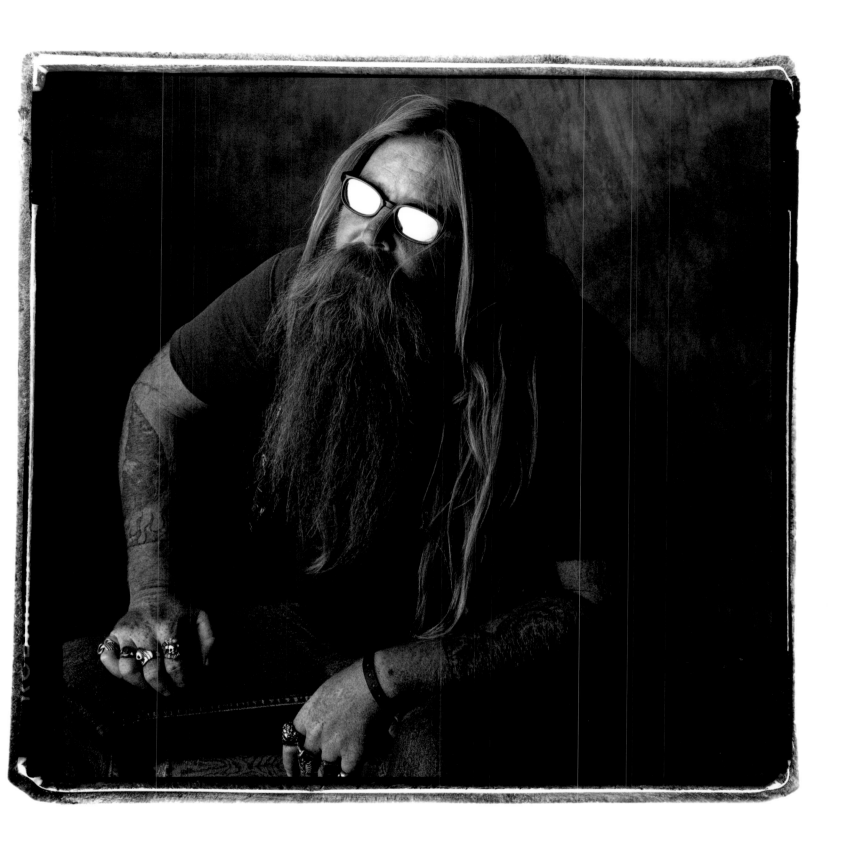

Rick Cross "RC" 1979 Shovel Head Simi Valley, California

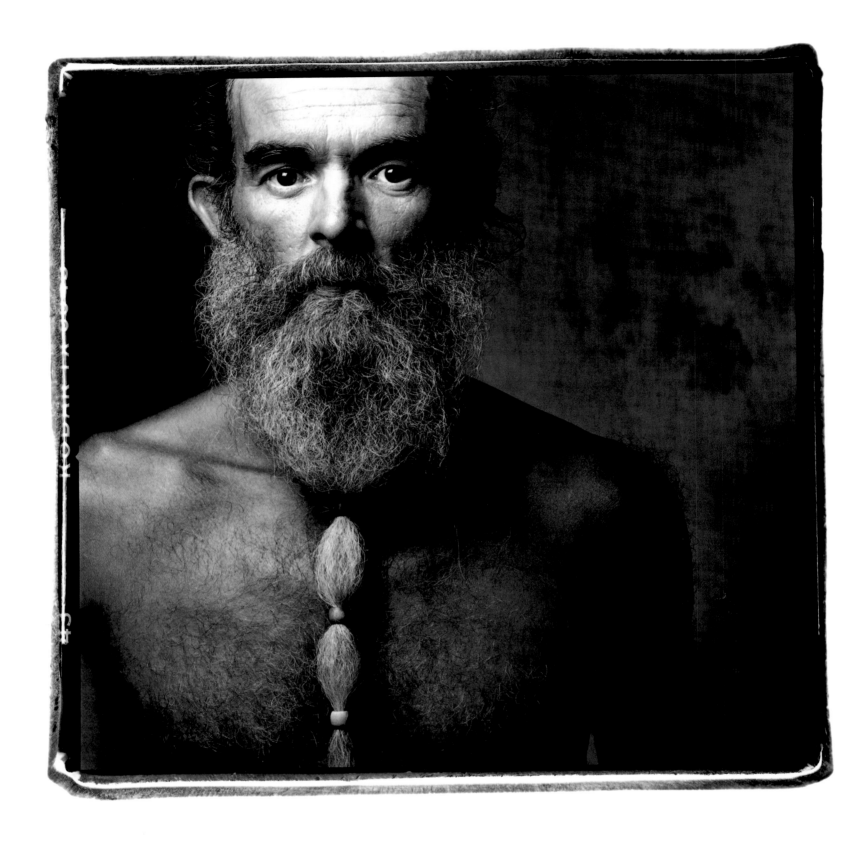

DaWayne E. Seaton "Butch" 1979 FLH Classic Full Dress St. Louis, Missouri

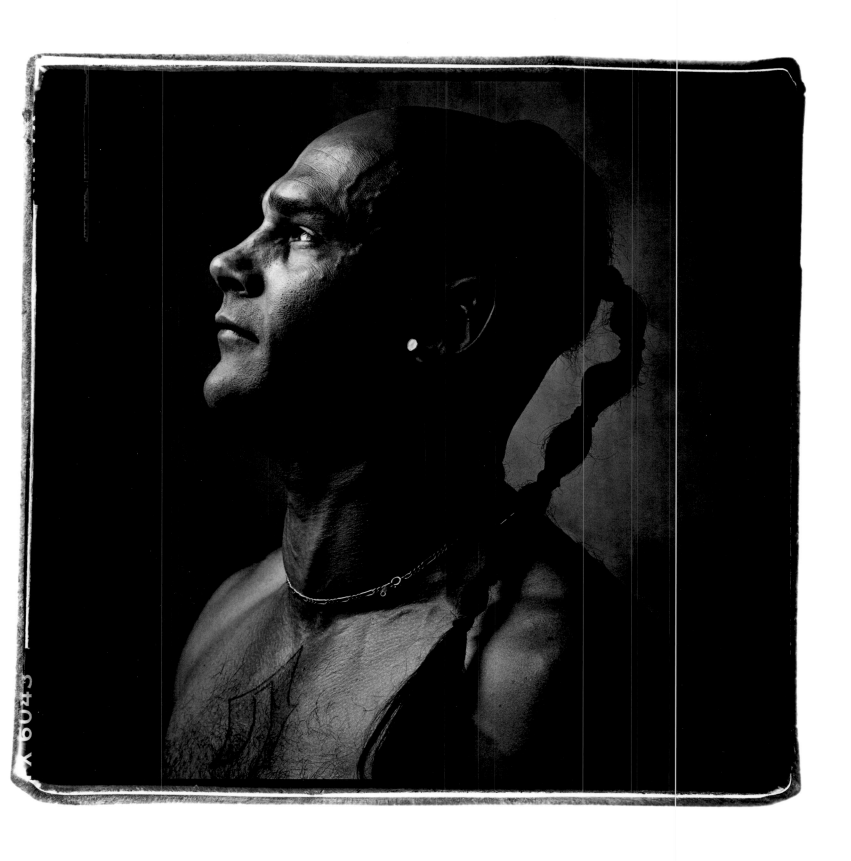

Chad M. "Mumbles" 1985 FXRP Cadillac, Michigan

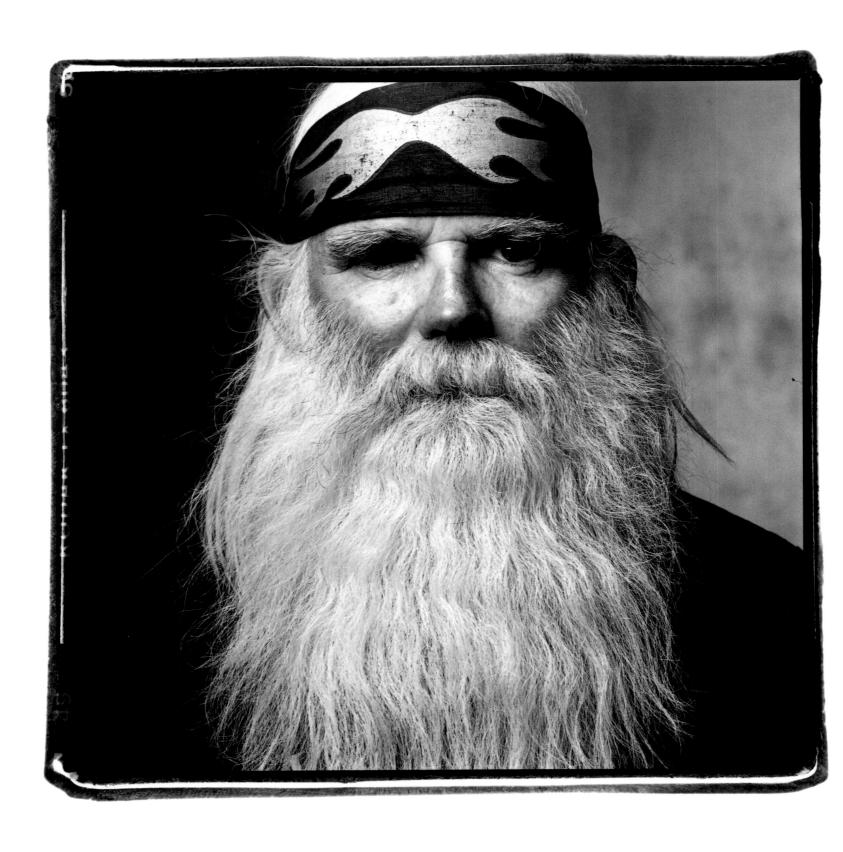

Blue Lewallen "Blue" Buick 3 Wheeler Wiser, Idaho

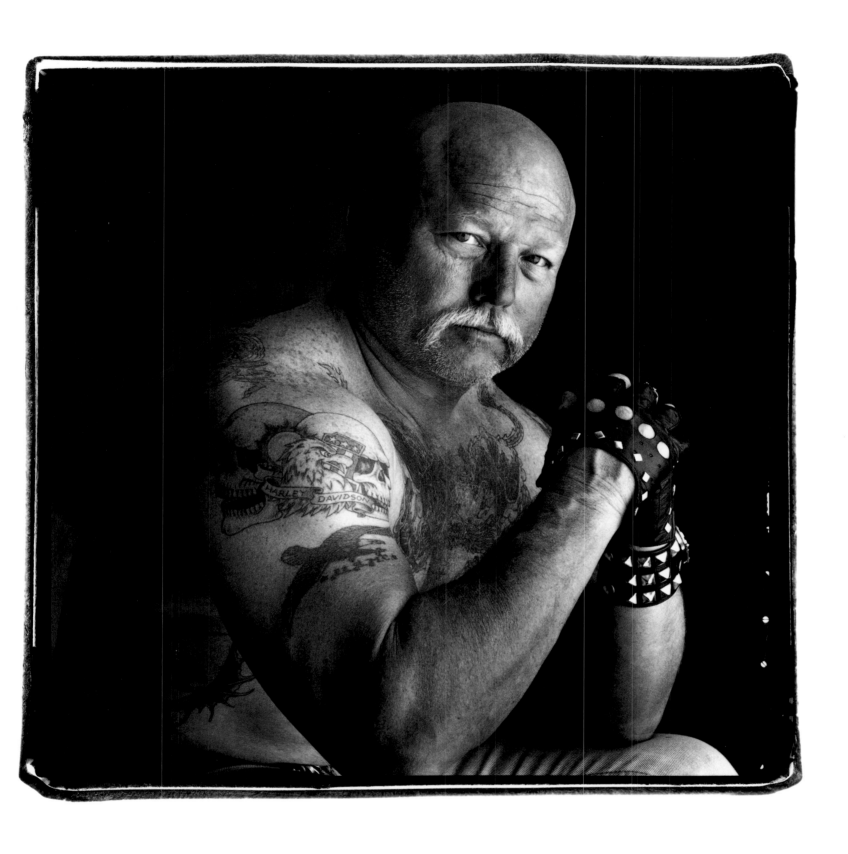

Lennie Cahill "Thumper" 1988 Lowrider

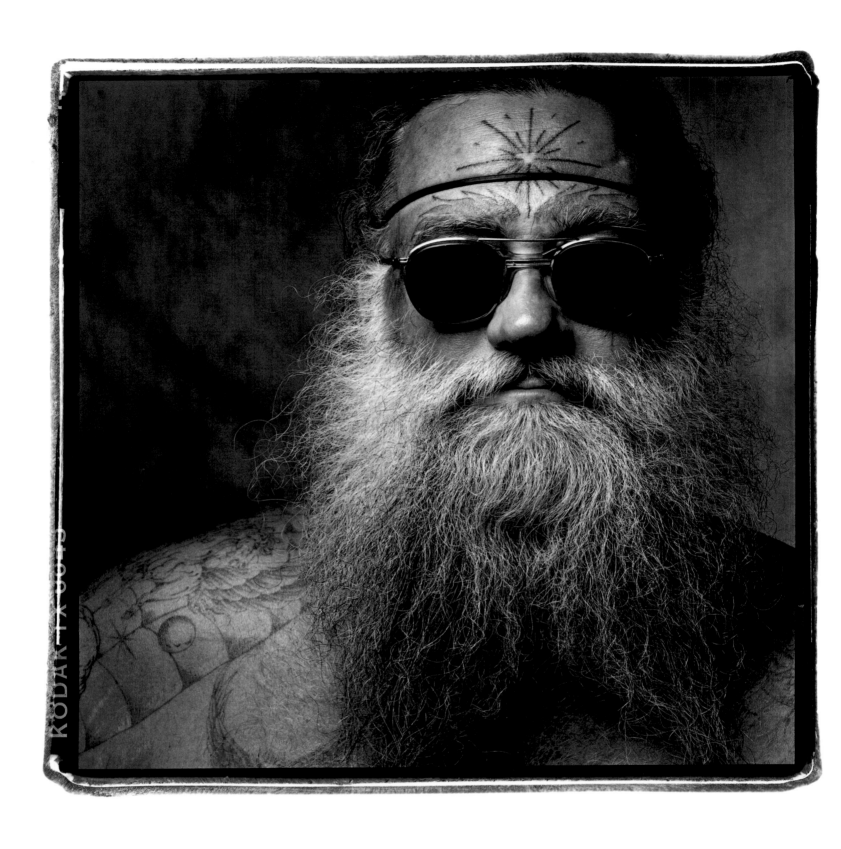

Don H. Vogler "Sandman" 1990 Heritage Brimfield, Illinois

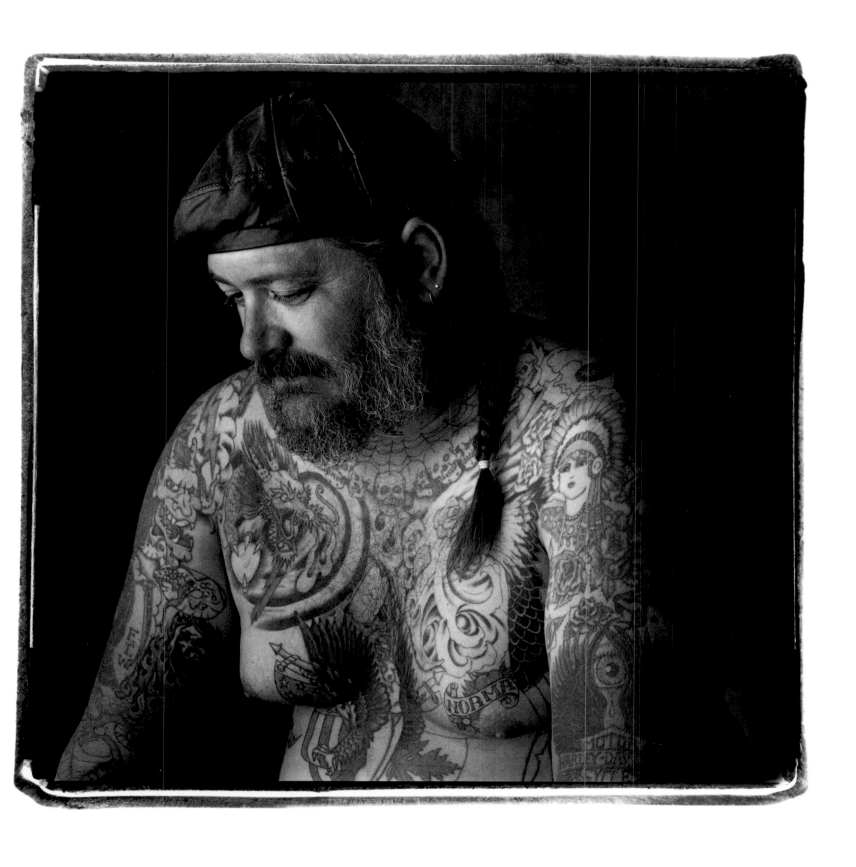

Skip Sonneville "Big Skip" 1969 Harley FLH New Philadelphia, Ohio

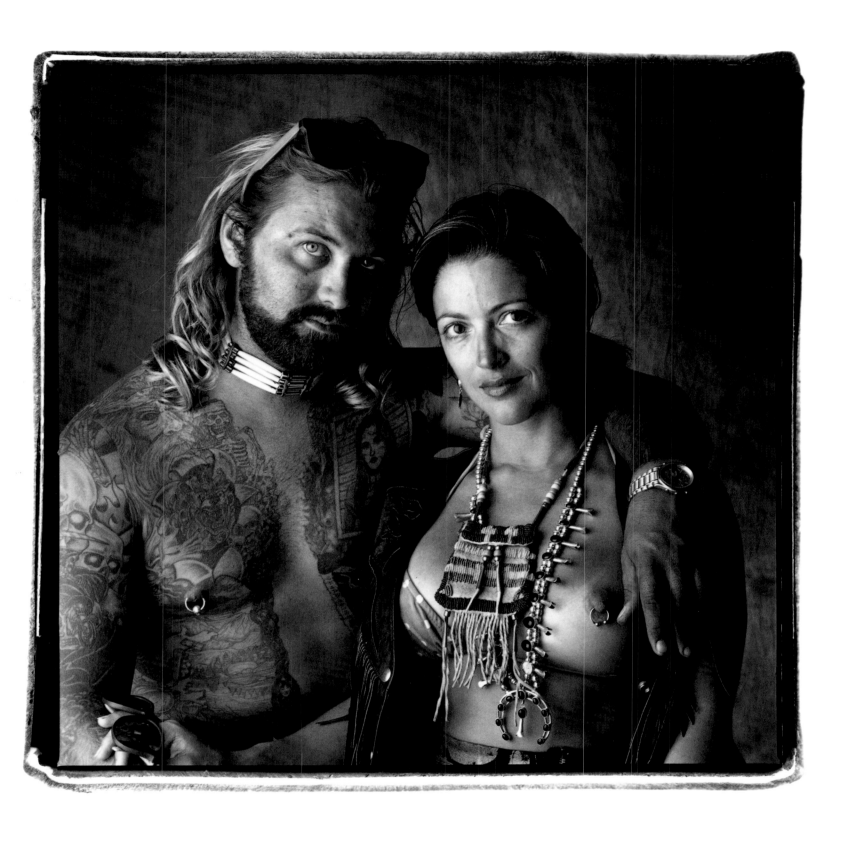

Marvin Mann "Swamp Man" New Orleans, Louisiana
L. Suarez "Gio" New Orleans, Louisiana

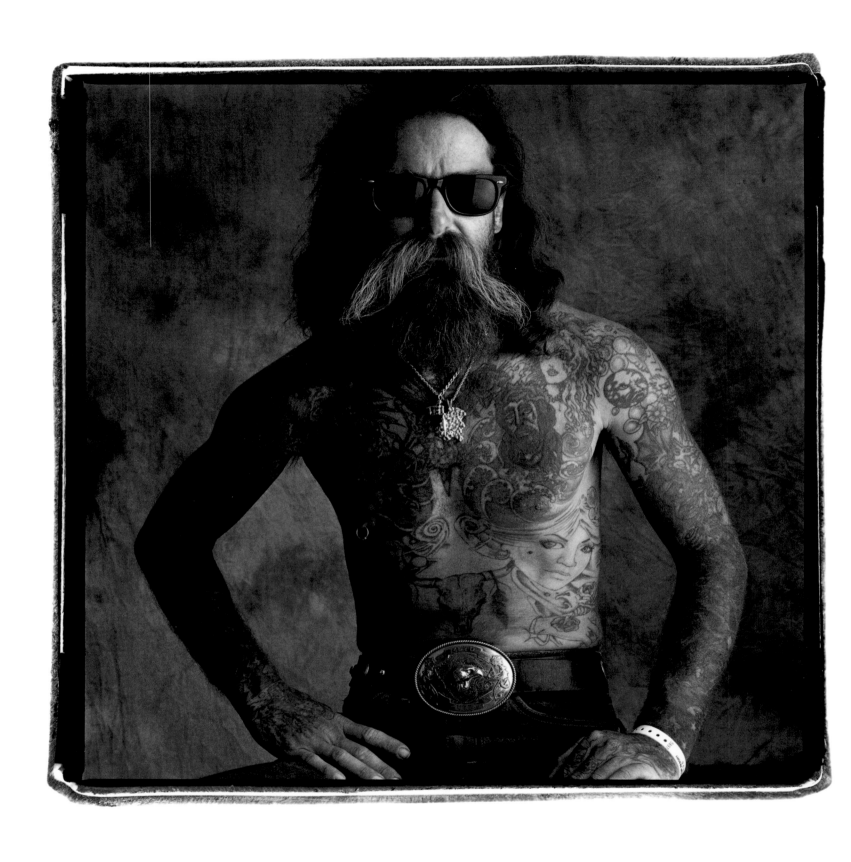

M. L. Miller, Jr. "Duke" 1996 Moto Guzzi Larimer, Pennsylvania

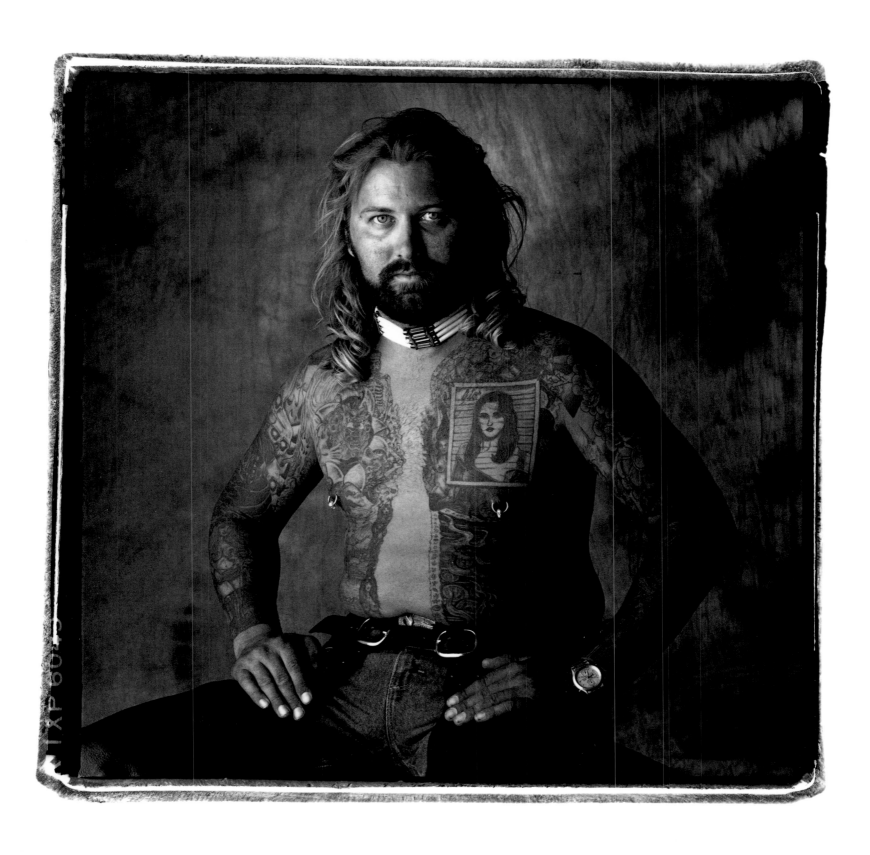

Marvin Mann "Swamp Man" New Orleans, Louisiana

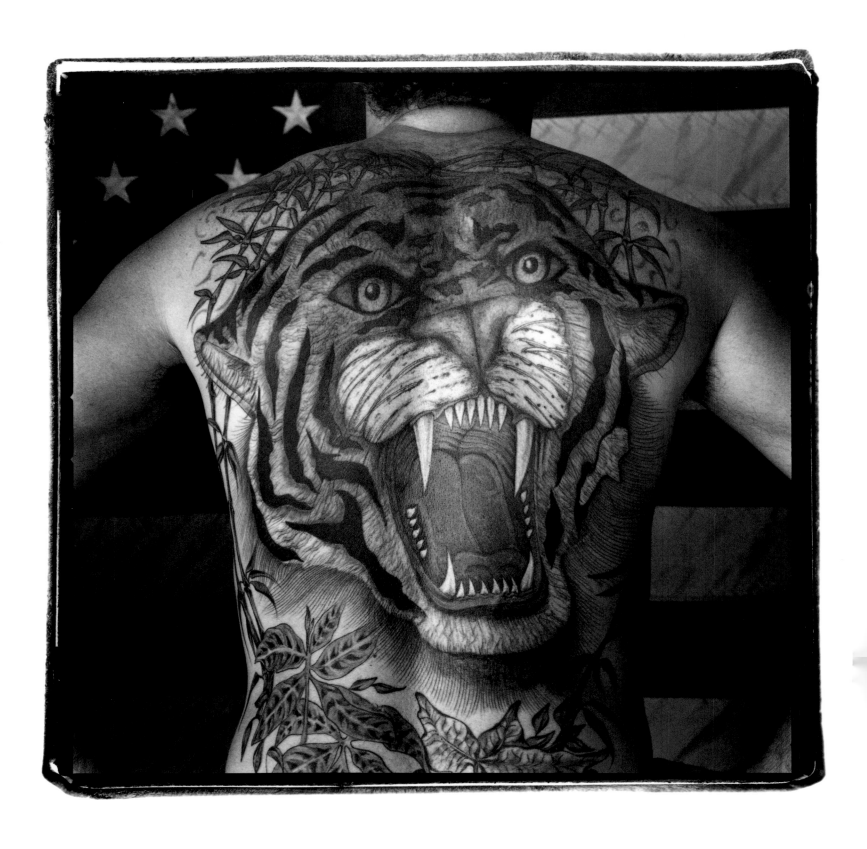

Jeffery James Clifton "Jimbo" Harley Davidson Full Dresser Chicago, Illinois

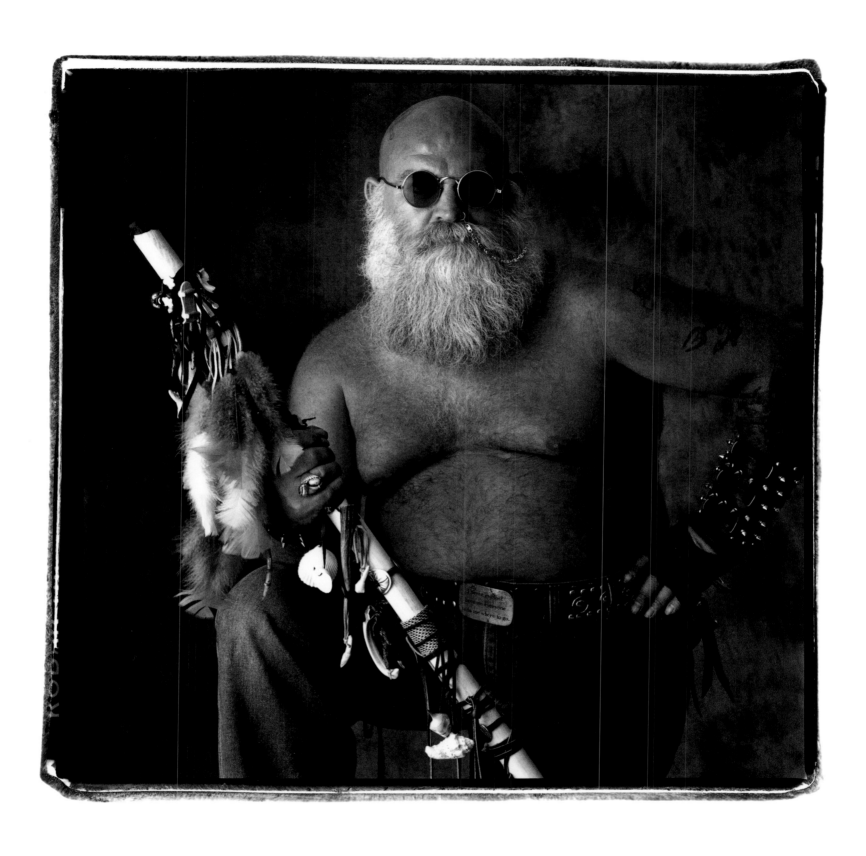

James Napierala "Nappy" VW 3 Wheeler Toledo, Ohio

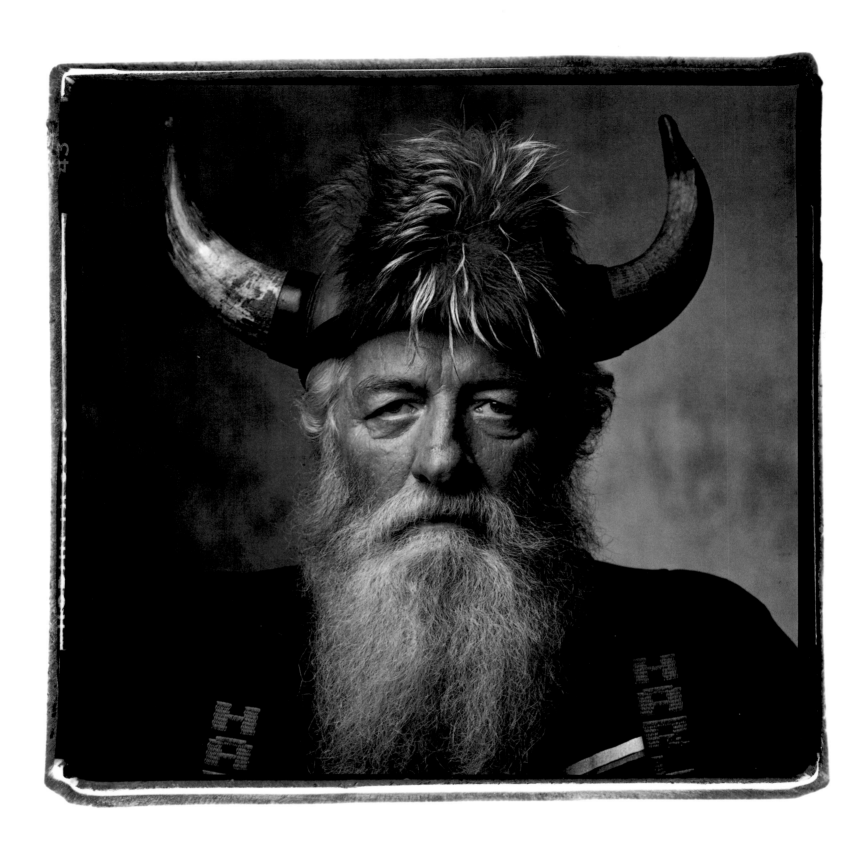

Lewis A. Rogers "Santa" XL 1200 Sportster Danby, Vermont

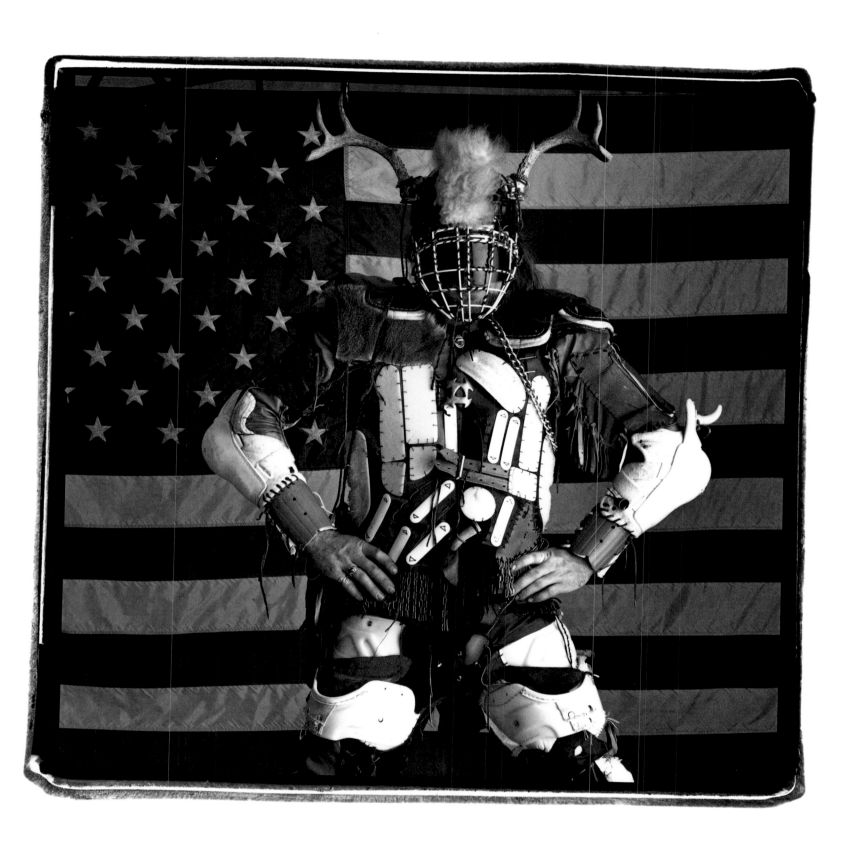

Tim Merritt "Tygre" Burlington, Vermont

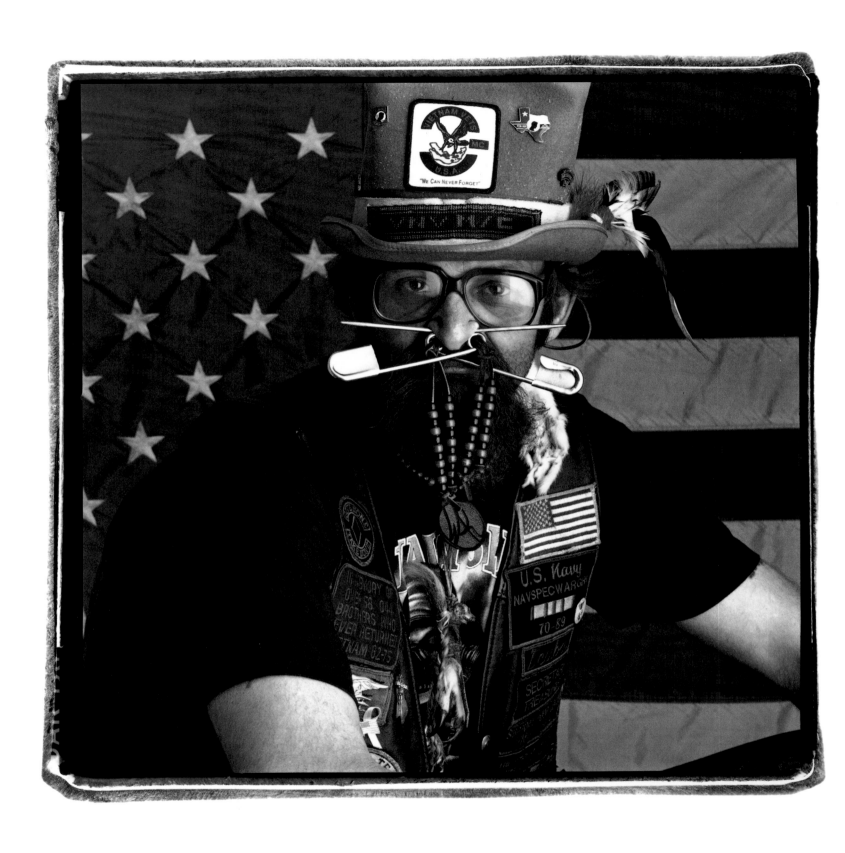

Chris Laws "Scuba" 1977 Shovel Head Leavenworth, Kansas

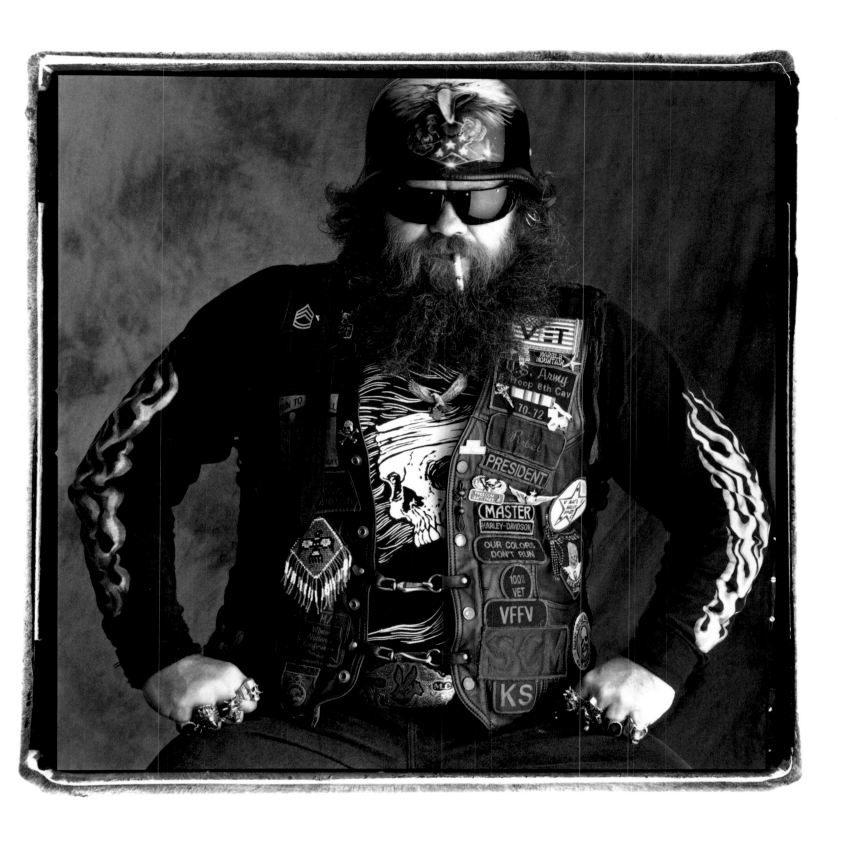

Rebel Haynes "Rebel" 1988 Custom Soft Tail Harley Leavenworth, Kansas

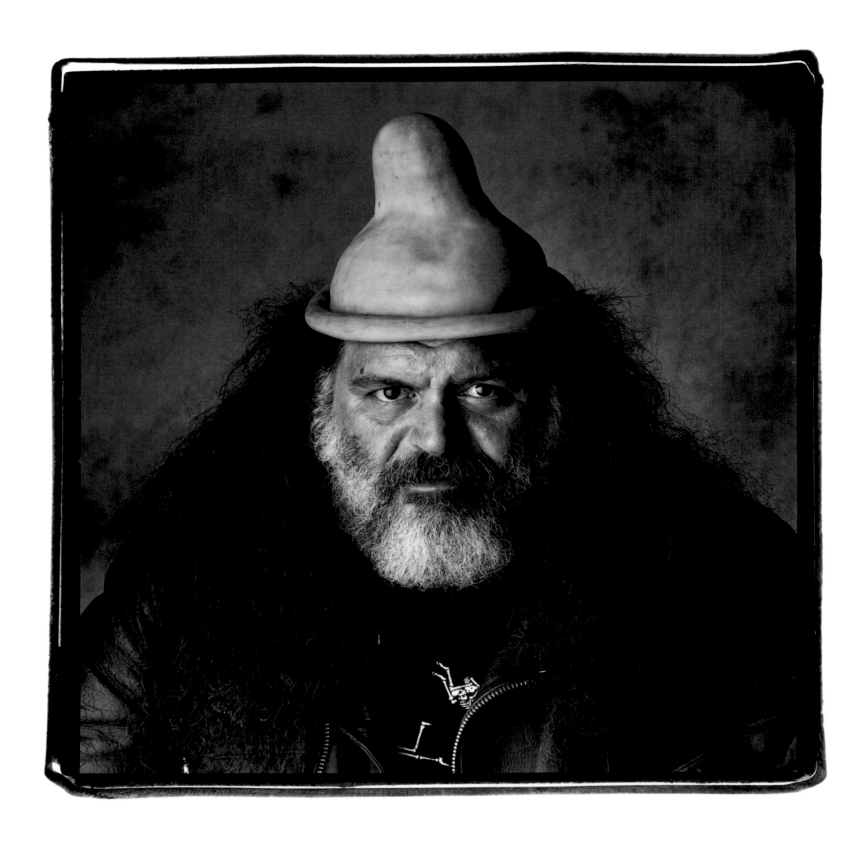

Brian Burdick "Willie Woo" 1300 Custom Harley Miami, Florida

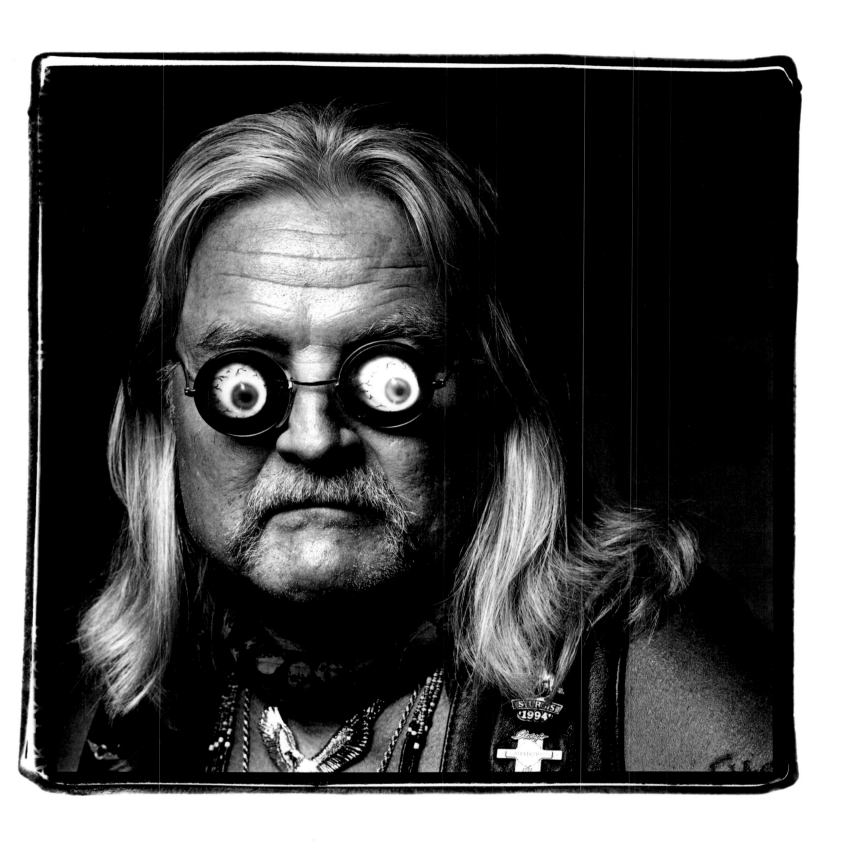

John M. Flanigan "Flag" 1990 Custom Soft Tail Harley Anahiem, California

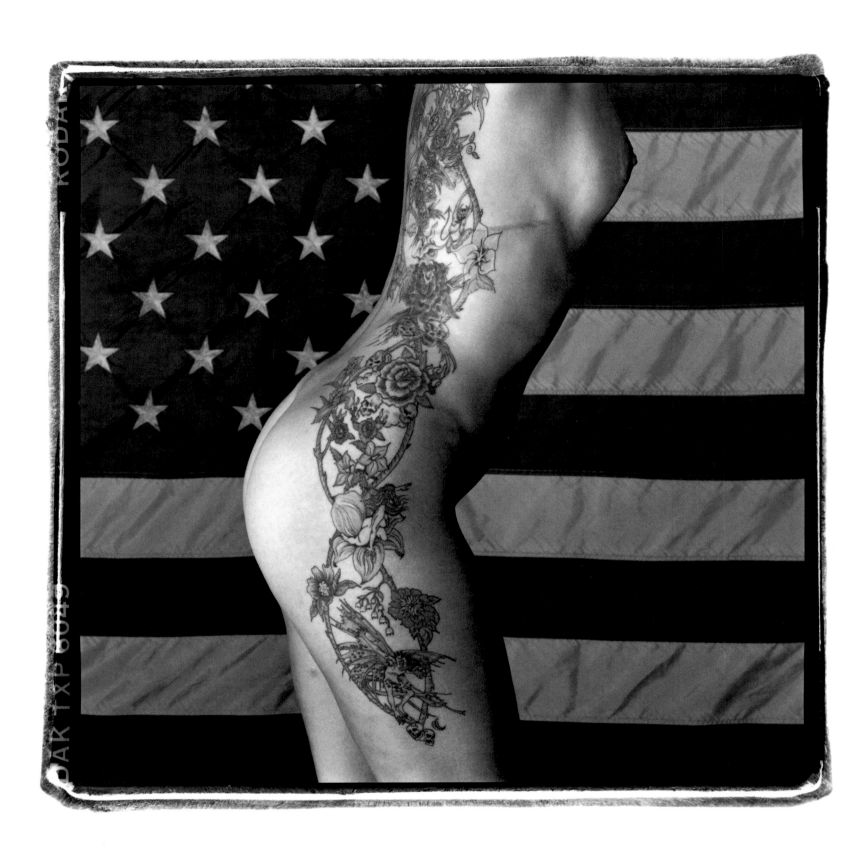

Paula Miluszewski "Pulsating Paula" 1971 Shovel Head/1947 Knuckle Head Somerville, New Jersey

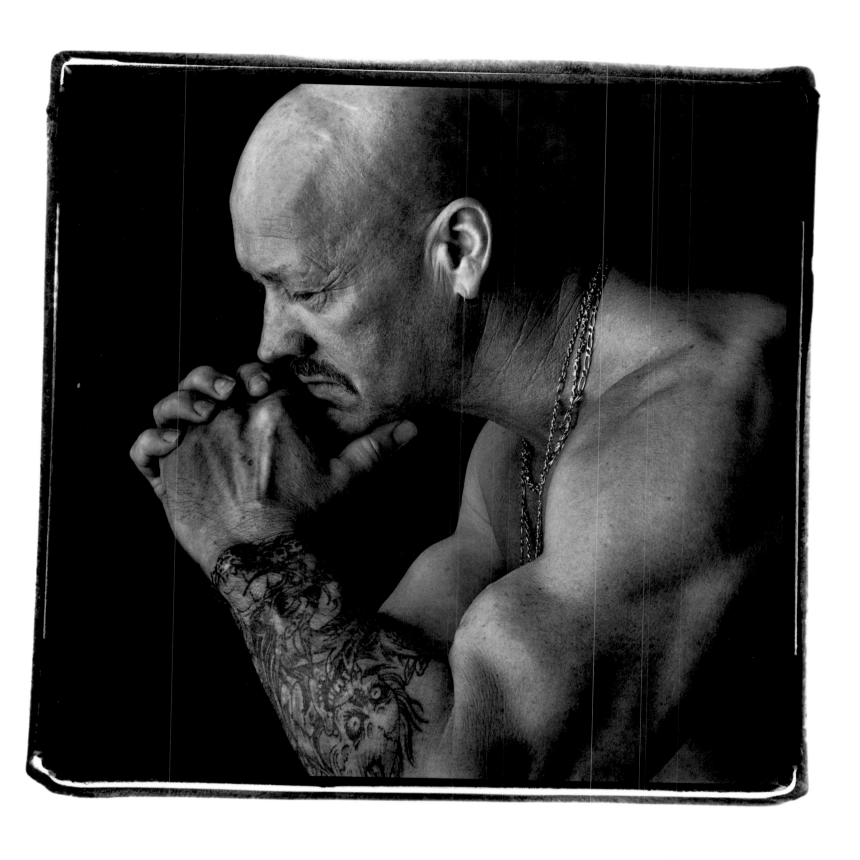

Ralph O'Neill "Too Smooth" 1965 Harley Indianapolis, Indiana

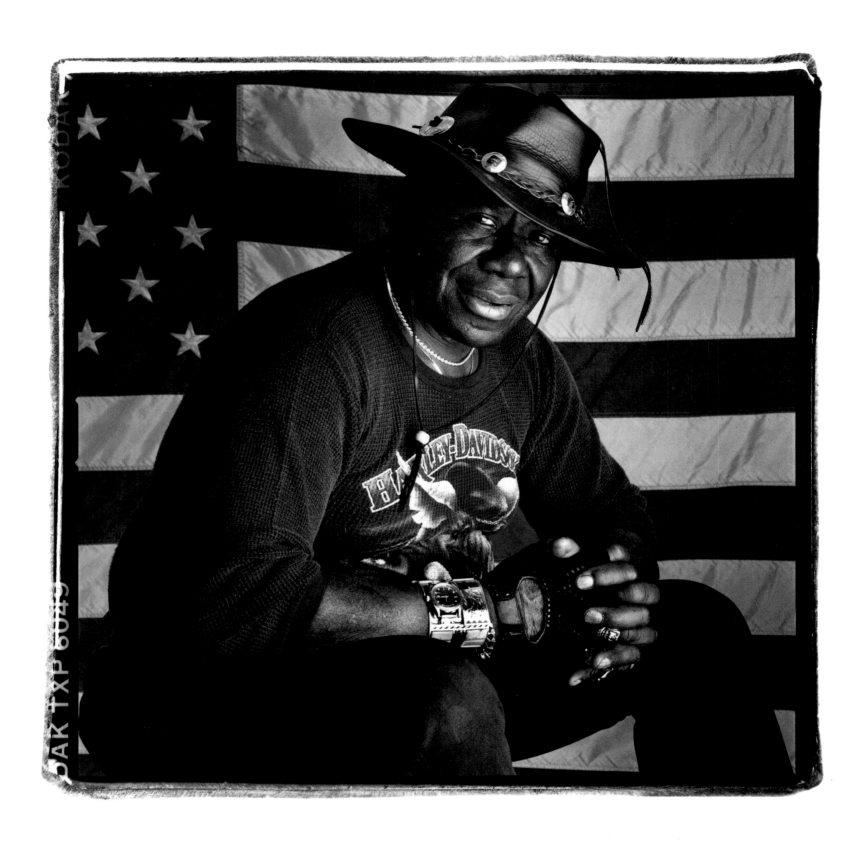

Bill Harris "Wild Bill" Harley E. Orange, New Jersey

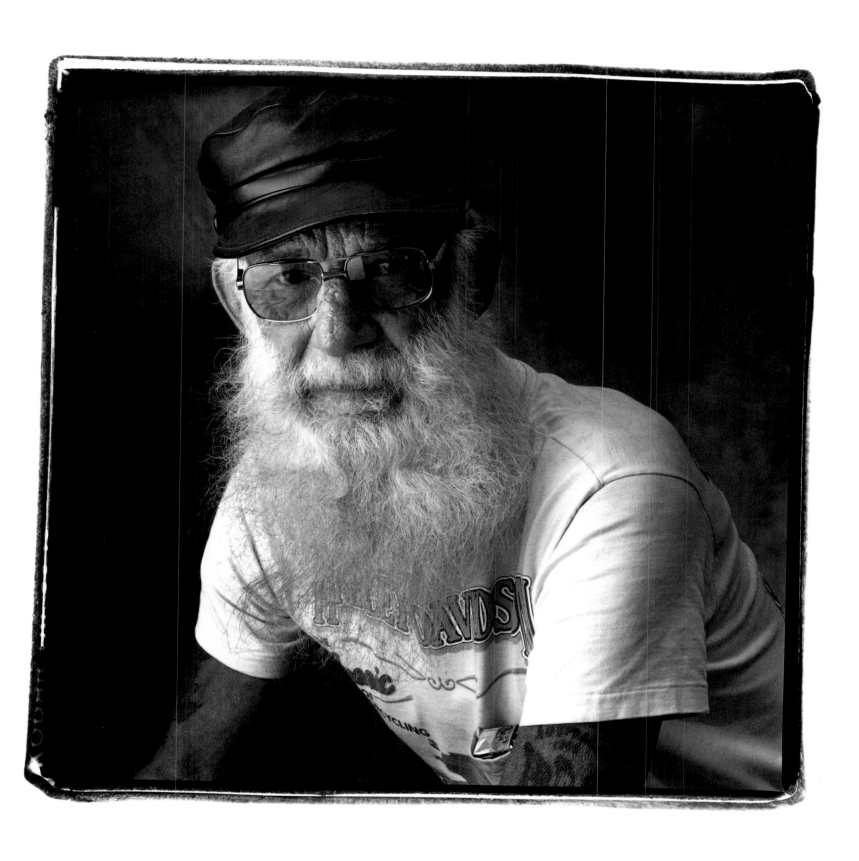

Leonard Wright Commerce City, Colorado

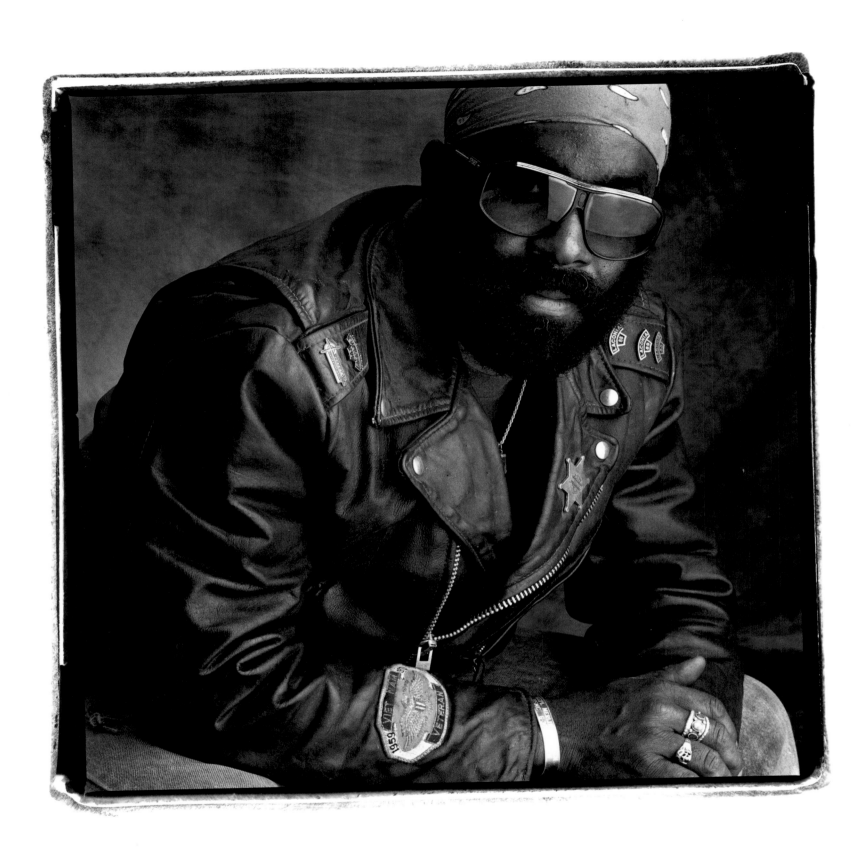

Stephan Carter Triumph/Harley Stamford, Connecticut

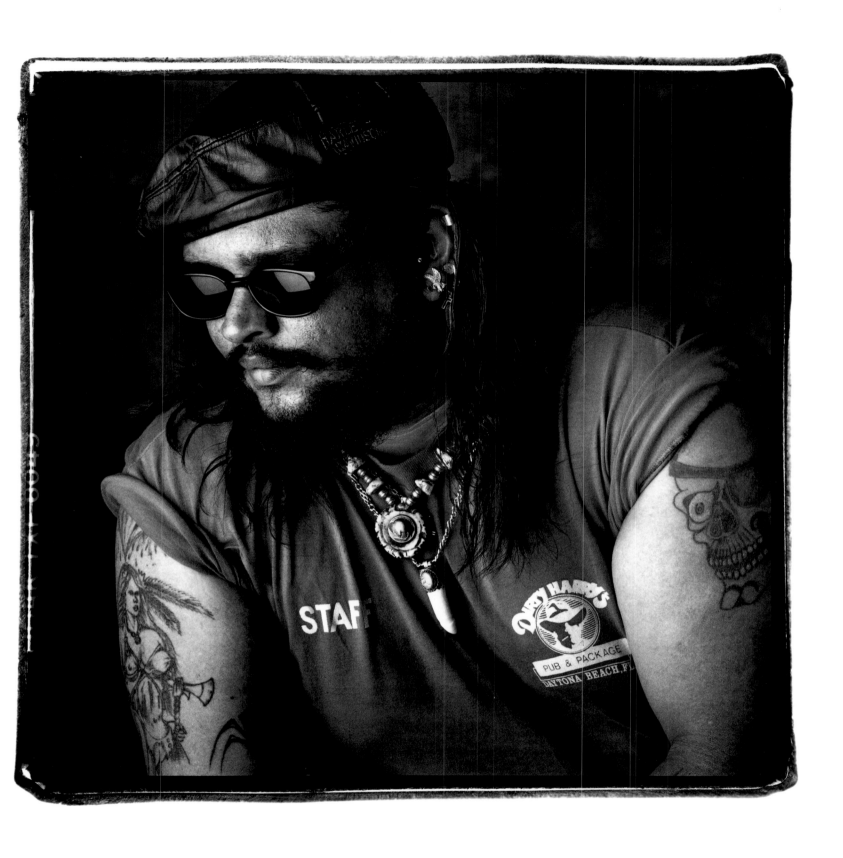

Val Santos 1987 FLH Daytona, Florida

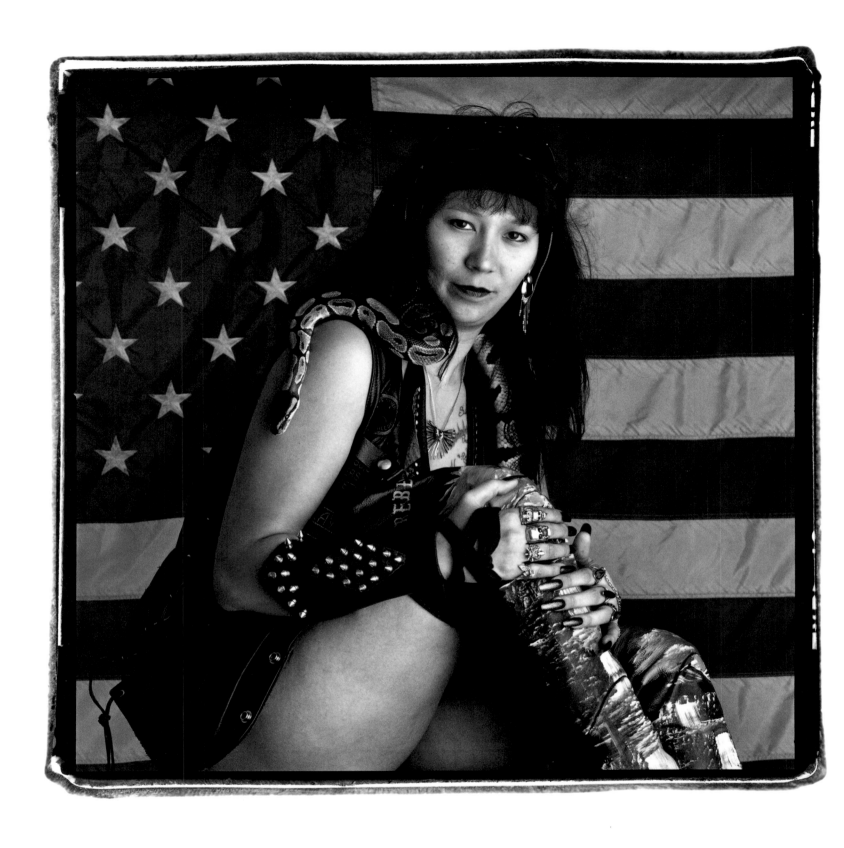

Shauna S. Haynes "Sunshine" 1988 Soft Tail Harley Leavenworth, Kansas

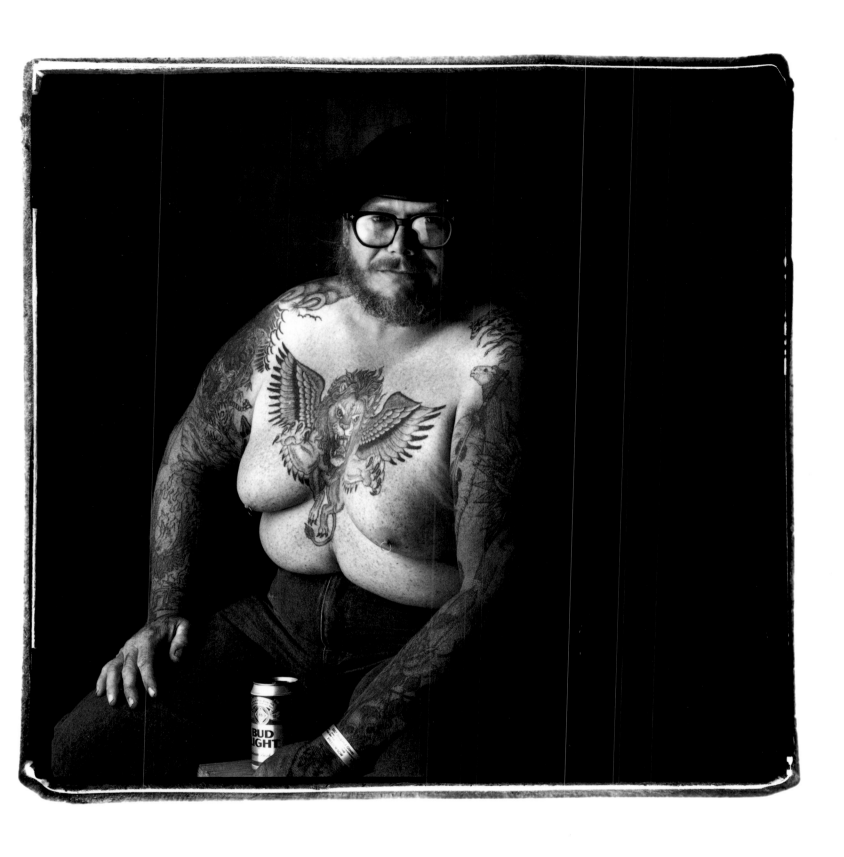

Munch Dulaney "Munch" 1970 Harley Electra Glide Nashville, Ohio

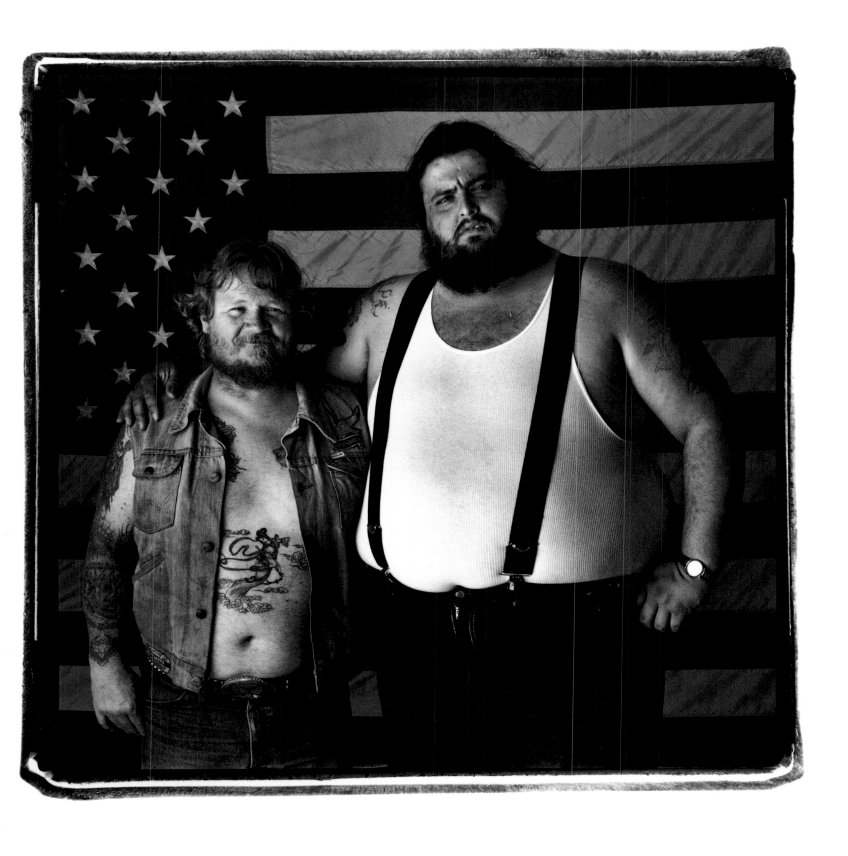

Wally Kerlin "Wally" 1974 Shovel Head Lanse, Pennsylvania
Wayne Gibbs "Big Wayne" 1982 Harley FX Lanse, Pennsylvania

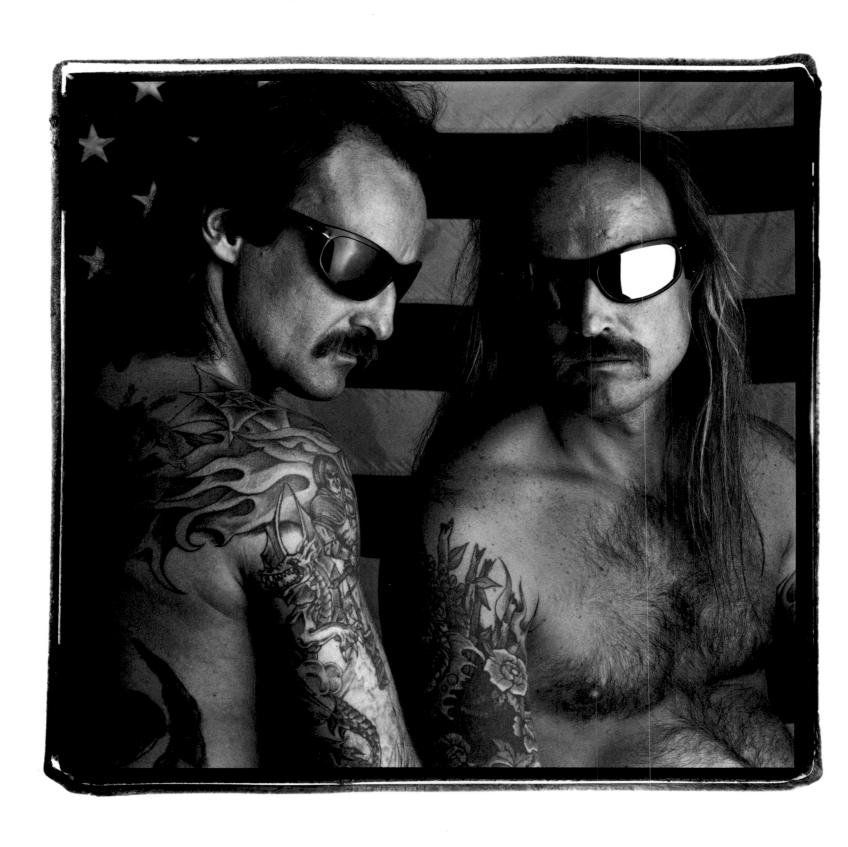

John and Mark Z. Buffalo, New York

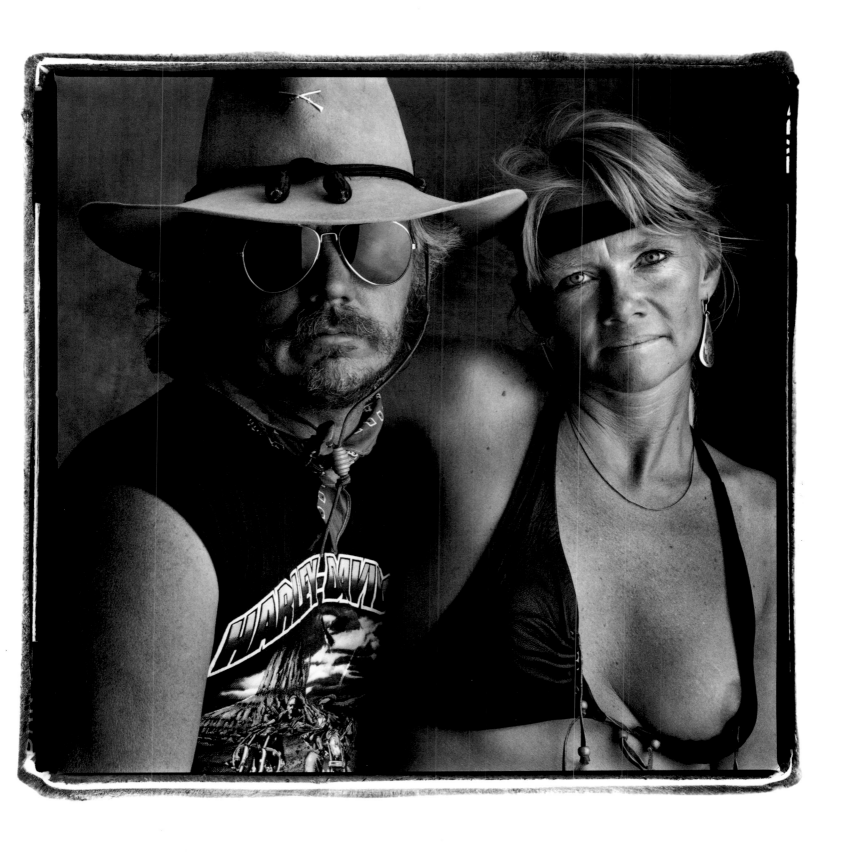

Tom and Kathy Austin 1993 Harley FLHS Eleva, Wisconsin

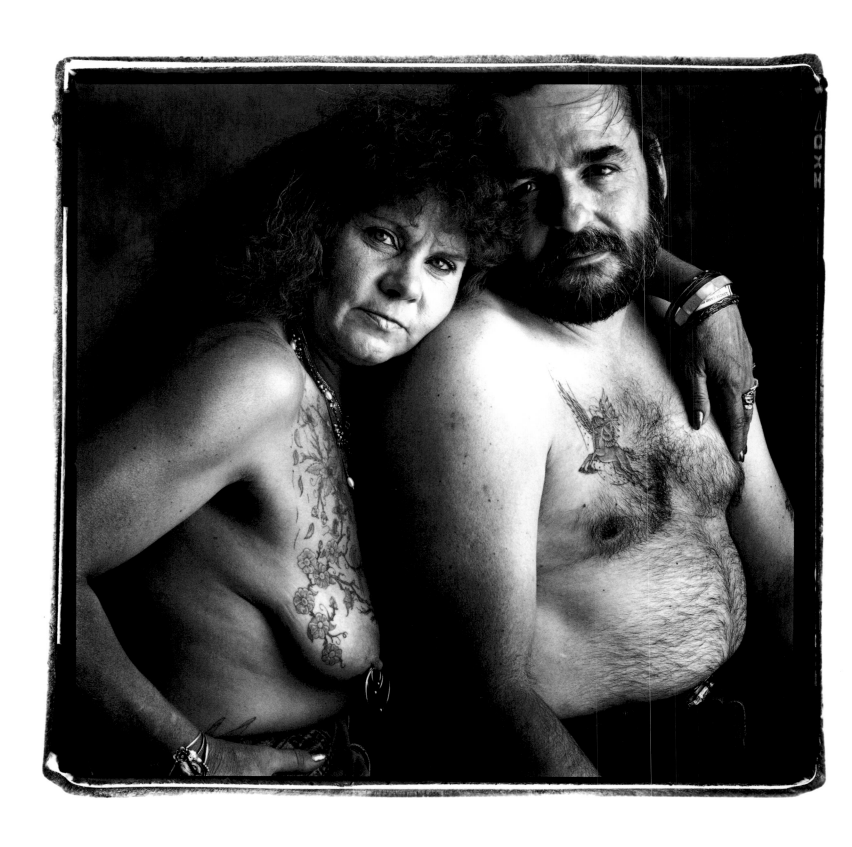

Lilly and James Morris

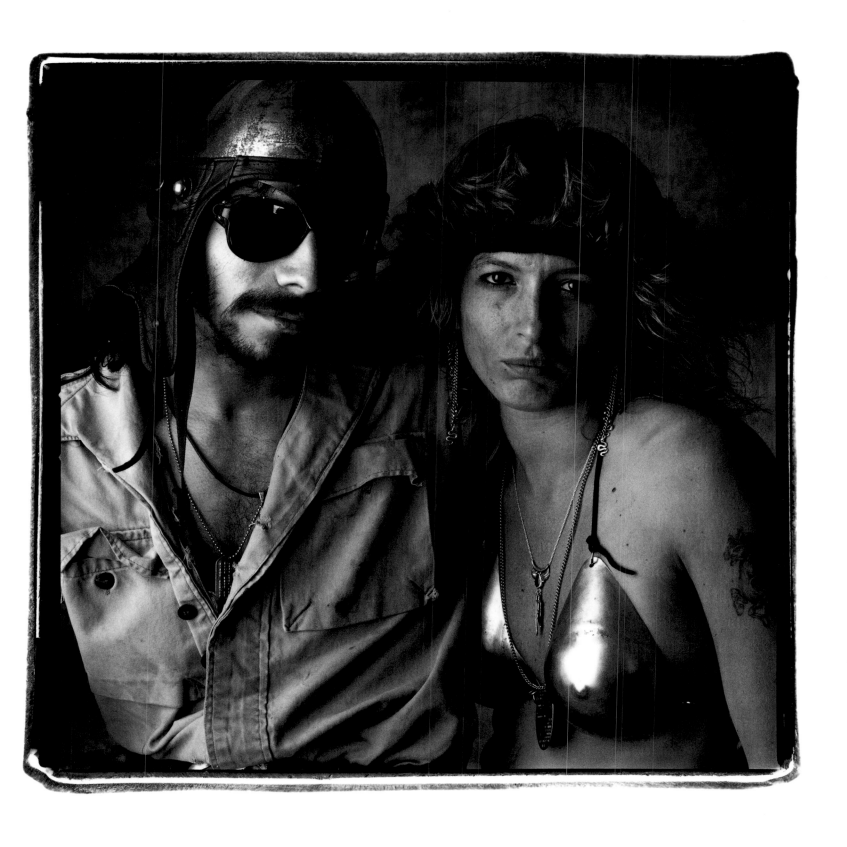

Soni Ulrich Honegger Fayettville, Arkansas
Cathy Hutchens "Legs" Fayettville, Arkansas

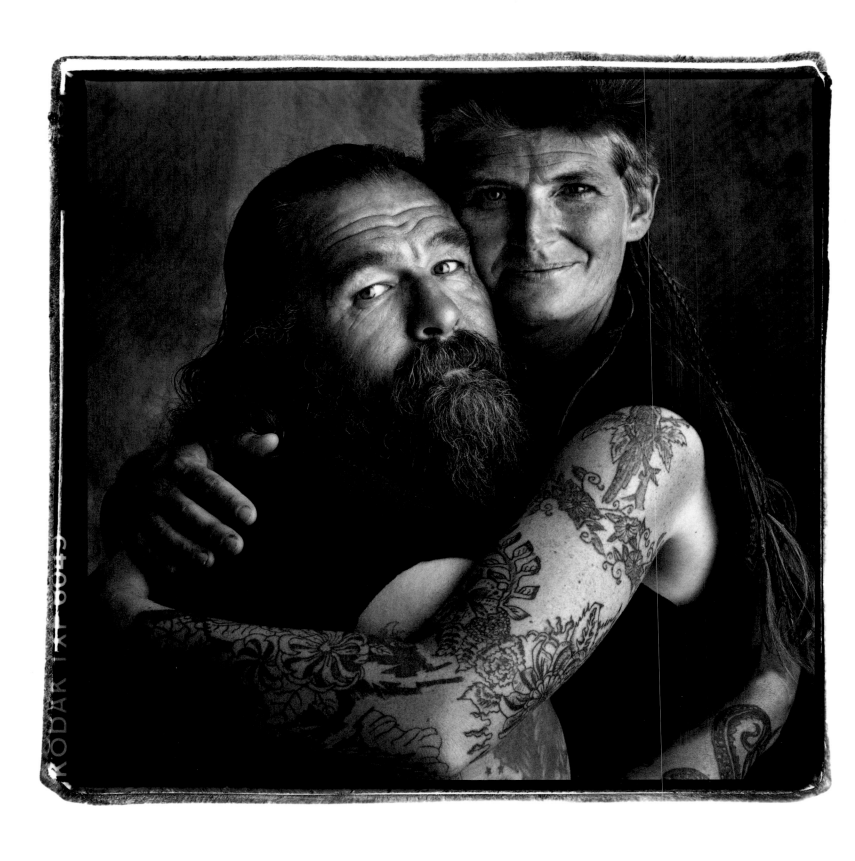

David and Diane Frandsen 1991 Soft Tail/1977 Shovel Head Rockvale, Colorado

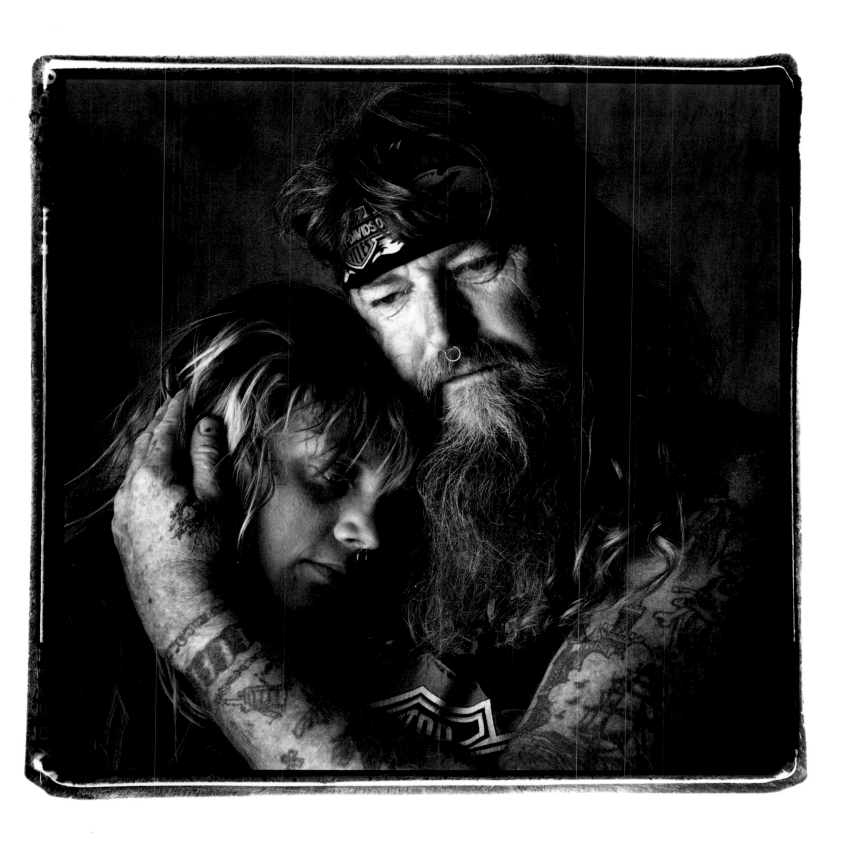

Anne Hughes "GA Anne" 1979 Lowrider Chester, New Jersey
Ron Fischer "Tuna Fish" 1979 Lowrider Chester, New Jersey

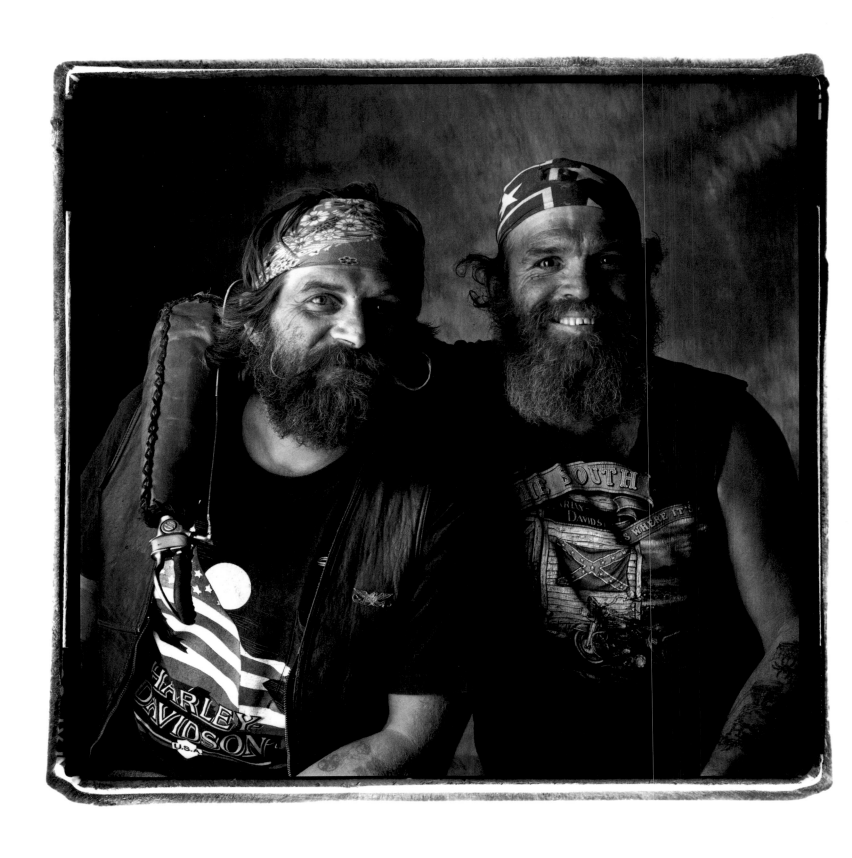

"Lunatic" and "Hook" Gladewater, Texas

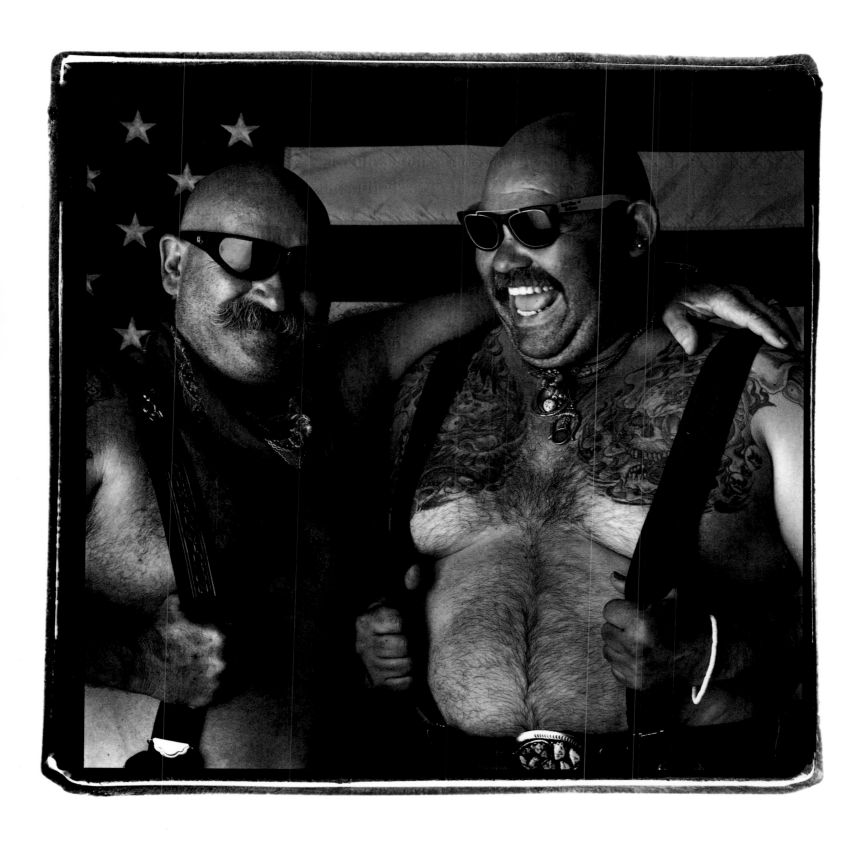

Gary Beck "Boss Hog" 1985 FLHTC Ft. Lauderdale, Florida
Joe M. Crisp "Mong" Harley Ft. Lauderdale, Florida

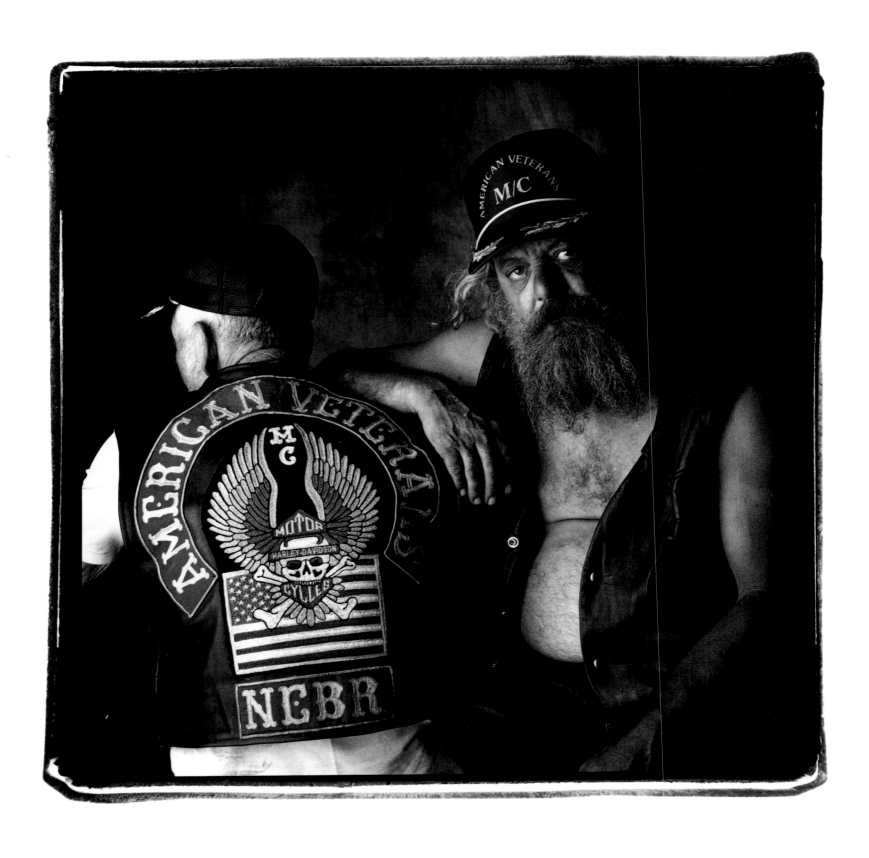

Joe Timms "JT" Sportster Columbus, Nebraska
James Faulkner "Jimbo" 1981 Wide Glide Columbus, Nebraska

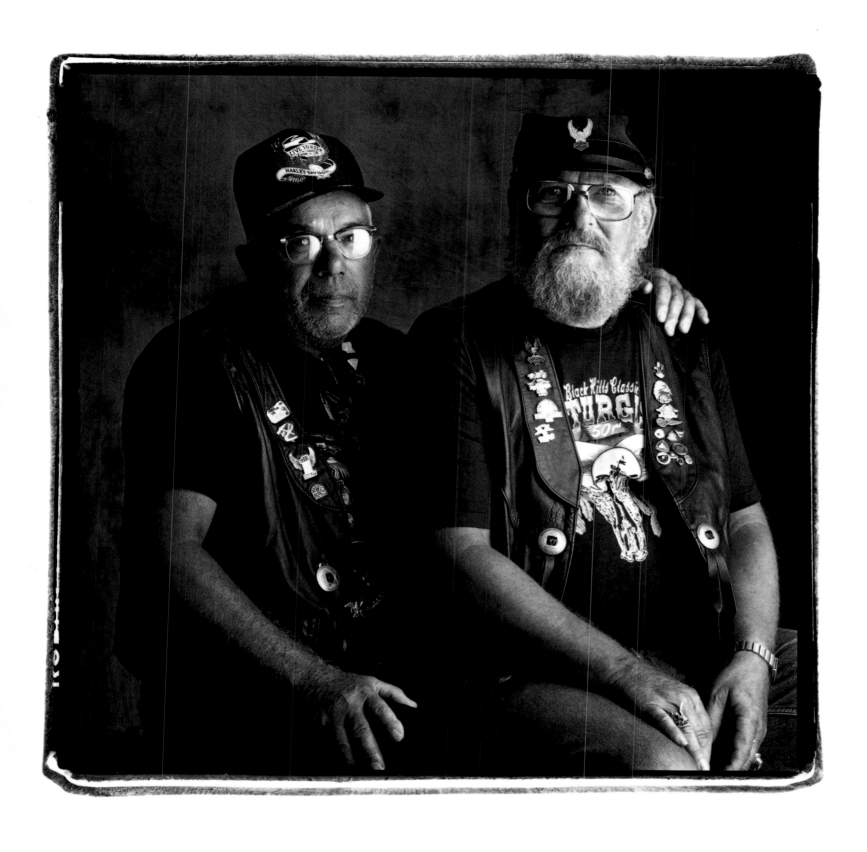

Mel Palenske Toledo, Ohio
Bob Jaska 1989 Full Dresser Toledo, Ohio

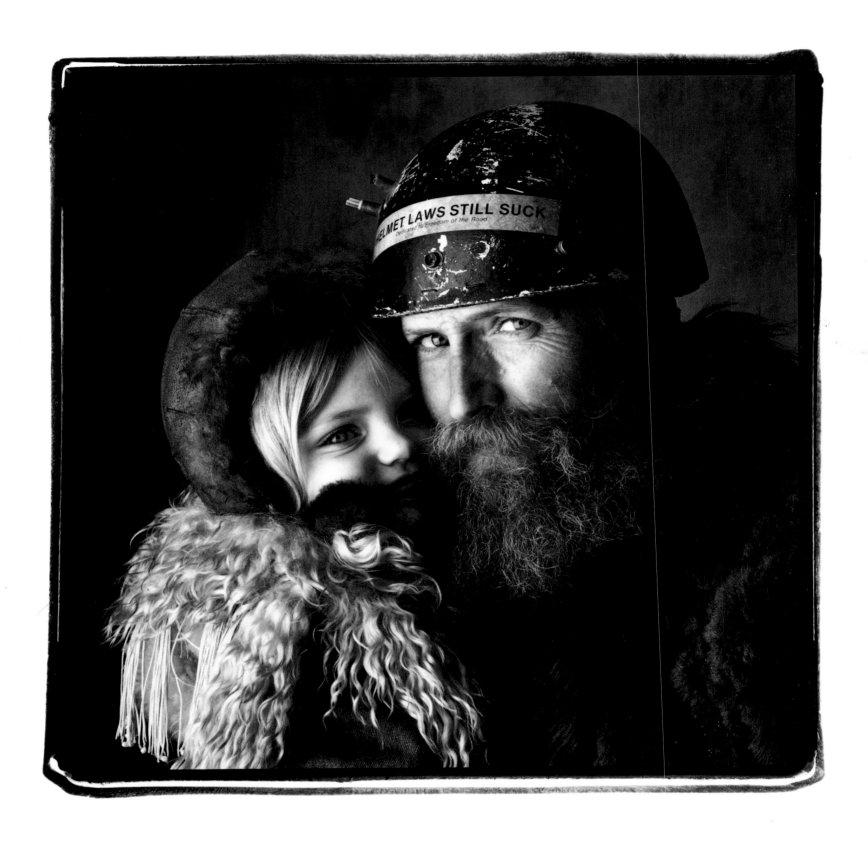

Michael "Biker Mike" and Michelle Hicks 1973 FLH/1976 FX Liberty Edition San Antonio, Texas